GEORGE GROSZ

The Artist in His Society

D1515746

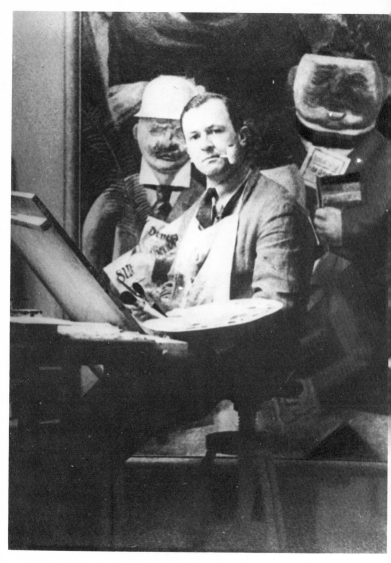

George Grosz in 1926. In the background is his painting *Pillars of Society* (see Color Plate 7).

GEORGE GROSZ

The Artist in His Society

By Uwe M. Schneede

Translated by Robert and Rita Kimber

Woodbury, N.Y. • London • Toronto

Front cover illustration: Detail from *Pillars of Society* (Plate 7)

Back cover illustration: Detail from *—the proletarian has to pay*
(Illus. 42)

Library of Congress Catalog Card No. 81-19074
International Standard Book No. 0-8120-2184-3

Library of Congress Cataloging in Publication Data

Schneede, Uwe M.
 George Grosz, the artist in his society.

 Bibliography: p. 195
 Includes index.
 1. Grosz, George, 1893-1959. I. Grosz, George,
1893-1959. II. Title.
NC1509.G78S3413 741'.092'4 81-19074
ISBN 0-8120-2184-3 AACR2
Printed in Shen Zhen, China.

123456 041 98765432

Contents

Consolidation and Contradiction (1924–32)

Emigration (1933–59)

From Childhood through 1913

Enthusiasms and Models

"The major educational influence in our lives was the black, white and red rod wielded by our arch-Prussian teachers. They were all Protestant, all reserve officers, and they believed in as military an education as possible. They inevitably would say: 'You want to be a good soldier someday, don't you? Then get hold of yourself.' And a word like that was usually sufficient" (Grosz[1]).

Georg Ehrenfried Grosz, born in 1893 in Berlin as the son of an innkeeper, grew up in the Germany of Kaiser Wilhelm II. During his childhood he lived in the provincial town of Stolp in Eastern Pommerania, from 1898 to 1900 and from 1902 to 1909. The rest of this part of his life was spent in Wedding, a working-class section of Berlin. "We lived in a truly proletarian part of the city, but I wasn't really conscious of that at the time." This environment nourished a lower-middle-class longing in him for a different kind of life, a life that he and many of his contemporaries found realized in novels. Robinson Crusoe, Leatherstocking and, above all, Karl May's Old Shatterhand were their idols. The intact world that May portrayed in his novels provided an escape from the dismal reality of Stolp and Wedding. As Grosz wrote later, "It seemed as if our unconscious dreams took on more reality if our thoughts—fed as they were on popular magazine articles and drawings—could float far away, high above the coal yards, the packed streets, and the cramped apartments of Berlin." Reality provided scenery for fiction: The

Stolpe River served as the Hudson; a garden shed became a log cabin in the wilderness. "In short, it was not the world of factories and offices, not the prospect of a sedentary life spent adding up columns that excited us. It was our fantasies" (Grosz).

The world of adventure provided the stuff of imagined wish fulfillment and, at the same time, served as a "corrective to an unsatisfactory reality" (Sigmund Freud[2]). The blurring of the distinction between fiction and reality was gratefully accepted, and fiction was "perceived as life itself. We identified with our heroes. In our imaginations, we took an active part in their adventures and became . . . these figures ourselves" (Grosz).

The young Grosz was particularly taken by the new serialized dime novels in which the same characters have a different and complete adventure in each issue. The Buffalo Bill series began appearing in Germany in 1905, Nick Carter in 1906, and Sherlock Holmes in 1907. The first two were translations. The Sherlock Holmes stories were plagiarized versions of originals by Arthur Conan Doyle. In 1908, the Nick Carter series appeared every week in an edition of 45,000. By 1911, 250 issues had appeared in this series.[3] Before World War I, the readership for pulp novels in Germany was about 20 million.[4] Grosz was one of those readers.

Glimpses of the Big World

The figures in the dime novels were, as Grosz put it, "our heroes and models. We would have loved to be like them, but the raw reality of our lives in Eastern Pommerania had little in common with the world we found between the colorful covers of these weekly pulps" (Grosz). Grosz did not regard these tales about Nick Carter and Texas Jack, Captain Storm and Buffalo Bill as trash or as mere entertainment. They were the essence of a literature that conveyed reality.

He drew his first creative inspiration from them. Nick Carter's "heroic deeds in the underworld prompted me to make some dramatic drawings. . . . And my school chum Hodapp even wrote a play in which Nick Carter and the notorious gangster king Carruthers had a highly dangerous encounter involving a privately owned electric chair. Taking the covers of the Nick Carter series as

models, I made several India ink drawings of this scene" (Grosz).

Almost all of Grosz's artistic efforts between the ages of ten and fifteen were based on ready-made scenes taken from pulp literature. "To this day I still get goose bumps from gruesome illustrations and magazine covers" (Grosz). But the covers of dime novels were not his only inspiration. He also drew on the military etchings and pictures of cavalrymen he saw in Stolp in the Prince-Blücher-Hussars' club where his mother worked after his father's death in 1900. The horror tableaux shown at fairs and shooting contests were another source. "Blood and gore was the major element in most of them" (Grosz).

In any event, "What appealed to me were usually rather crudely executed representations of sensational events." Assassinations, catastrophes, manhunts, executions, murders, and shipwrecks conveyed to him "the romanticism of a big world that was still unknown to me and that was full of great danger and bloody adventures" (Grosz).

Although he was subjected to the rigors of Wilhelminian education at school, Grosz's youth was otherwise remarkably free. His mother was working and did not have much time to supervise his activities. Grosz could read, draw, and play cowboys and Indians all he liked. He grew up "completely unhampered and on [his] own hook" (Grosz). The contrast between this personal freedom on the one hand, and the oppressiveness of school, of lower-class provincial life in Stolp, and of the slums in Wedding on the other, fed Grosz's yearning for experiences that would compensate him for the drabness of his surroundings and put him in touch with the big world.

Every once in a while the big world put in a brief appearance in Stolp. In his autobiography, Grosz tells how the Paris–Petersburg Express used to pass through Stolp once a week: "As it raced by, we sometimes caught a glimpse—through a half opened window—of a strangely beautiful face. Maybe she was an actress, maybe even one of those dancers we had seen only on those incredibly beautiful photo postcards that were all the rage then." And sometimes the Barnum and Bailey Circus came to town. "I would have given anything to roam the world with these tightrope walkers and jugglers and to live in one of their white wagons richly ornamented with gold. (I would not go as myself, of course, but as a world-famous stunt man or trapeze artist)" (Grosz).

Finger Exercises

When Grosz published his "Jugenderinnerungen" [Recollections of my youth] in 1929[5], the first installment was accompanied by illustrations that show how the interests he had as a boy in Stolp kept cropping up in his drawings again and again. The Blücher hussars, Indians, battles, and scenes with knights in them were the favorite themes in the years 1904 to 1908. It was not until a few years later that Grosz began to draw murders, circus artistes, and the freaks he had seen in the Barnum and Bailey sideshow.

In his efforts to understand pictures and make them his own, the young Grosz copied anything he could get his hands on: reproductions from such popular magazines as *Die Gartenlaube, Daheim, Jugend* and *Fliegende Blätter,* and from Velhagen and Klassing's monographs on artists. He also imitated or copied works by Wilhelm Busch, Moritz von Schwind, and Ludwig Richter.

In 1909, Grosz was thrown out of school just before he was to take his final examinations. He had struck back at a teacher who had struck him. That same year, he began his studies at the Royal Academy in Dresden. He studied under Richard Müller there, as did Kurt Günther, Bernhard Kretzschmar, and Franz Lenk. "Professor Müller ruled with military discipline, a maulstick, and a dozen lethally sharp pieces of chalk" (Grosz). The students concentrated on drawing from plaster casts. "Our devout efforts went into creating a life-size photograph in chalk." Grosz and his fellow students rebelled against "this mindless copying" that Müller forced on them. Müller combined Max Klinger's artistic principles with unimaginative technical perfection and, in the 1920s, produced drawing-room art based on youth movement themes.

Grosz claimed he learned from Menzel "that diligence, sheer persisting work, is more important than talent." He concentrated all his energies on sketching outdoor scenes and filled dozens of sketch books, which have been preserved. "This work was especially useful for me because up to that time I had been drawing almost entirely 'out of my own head'. . . . This rapid sketching taught me to see much better than all those days spent squinting at my thumb and pencil trying to get proportions just so. And I still think that this kind of sketching is the best training for a draftsman

and the most solid foundation for journalistic work and illustrating."[6]

Die Brücke, with Heckel, Kirchner, Pechstein, and Schmidt-Rottluff among its members, was in its heyday in Dresden at this time, but Grosz was totally unaware of these artists and their work because nothing like that "penetrated the thick walls of the academies or the thick skulls and glasses of the state's art teachers" (Grosz). (*Die Brücke* [The Bridge] was a group of Expressionist artists [translators' note].)

At this time Grosz was reading Gustav Meyrink, Hans Heinz Ewers, Barbey d'Aurevilly and, a little later, Flaubert, Maupassant, Strindberg and Wedekind. "Despite an innate tendency toward the fantastic, the grotesque, and the satirical," Grosz now developed—as he himself put it—a "marked interest in the real world."

Grosz had still not rid himself of his attachment to popular magazines that catered to the whole family. Grosz wanted to become an historical painter and do some work in the style of Grützner on the side, portraying "monks enjoying a glass of golden wine." He even planned a painting that would be called "A Refreshing Drink." A "beautiful girl" at a "picturesque counter" would be handing a hussar "a large glass filled with a glowing, golden liquid. . . . Everyone in the painting would be dressed in old traditional costume" (Grosz). What Grosz considered desirable was a direct reflection of what the reactionary petit bourgeois expected in art. The Nazis would cater to these tastes. Grützner was one of Hitler's favorite painters. It is worth mentioning, too, that Richard Müller signed Otto Dix's letter of dismissal in 1933 and that he was one of the organizers of the Nazi exhibit "Degenerate Art," which attacked, among other artists, his own students Dix and Grosz.[7] Writing about this period before World War I, Grosz said, "It goes without saying that I was completely 'apolitical.' "

To scrape together some money, Grosz drew cartoons for satirical periodicals. He was much influenced by Lyonel Feininger, who had been working for *Ulk,* the humor supplement of the *Berliner Tageblatt,* since 1895 and for the *Lustige Blätter* since 1897. In 1910, Grosz had his first publication in *Ulk* (Illus. 1). This drawing is a skillful imitation of the Art Nouveau illustrations that were appearing everywhere at that time.

1 Illustration for *Ulk,* 1910

Grosz's ambitions in this period pointed in three distinct directions. First was conventional historical painting in the style of Grützner, a style that Grosz considered "high" art and that embodied Grosz's professional ambitions in the realm of great art. Second was the systematic appropriation of elements from reality by sketching objects and landscapes. He regarded this kind of work as a purely manual skill and considered it much less prestigious than historical painting. Third was the fashionable field of Art Nouveau illustrating, which Grosz hoped would bring him both income and fame. Several levels of pictorial expression often appear simultaneously in most of Grosz's work. However, his subject matter and

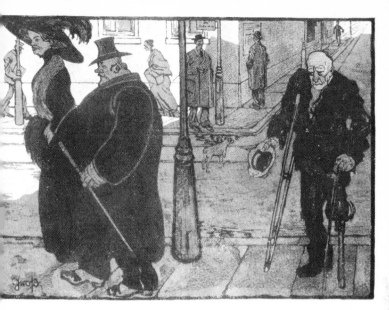

2 Illustration, 1911

the emphasis given these levels underwent considerable change. For the time being, it is sufficient to note that Grosz—in full accord with academic values and traditions—worked on several levels.

From 1912 on, Grosz attended art school in Berlin because as a citizen of Prussia, not of Saxony, he could not get a scholarship in Dresden. Prewar Berlin offered a multitude of attractions to which Grosz responded eagerly: jazz and night life, department stores and carnivals, revues and six-day bicycle races, international tango competitions and modern art.

In Berlin, Grosz came under the influence of Emil Orlik, an experienced illustrator who was less academic and much more

3 *Street Crowd Gathering,* 1912

open-minded than Richard Müller. In art school, Grosz produced extensive series of nude drawings in which a shorthand translation of reality into image and a rough stroke indicated a new independence in Grosz's style. In this same period, he also did a number of charcoal drawings of workers that were composed more carefully and were reminiscent of Orlik. Another favorite theme was the natural world as it appeared in those desolate border areas on the outskirts of a big city. Many of these sketches were done in the South End, where Grosz was living at the time. What is striking

in these pictures is Grosz's focus on the banal, on the completely unpicturesque, his preoccupation with those areas in which the city is no longer the city and nature not yet nature.

Social concerns still were secondary to Grosz's need to appropriate his environment in pictorial terms. But it is also clear that Grosz now was much more interested in the impoverished people and sections of town than in the charms of shimmering liquids in a glass or in the apparent worldliness of the Paris–Petersburg Express.

In 1913, Grosz went to Paris for a few months. He perfected his sketching technique by doing unretouched five-minute sketches in Cola Rossi's atelier, where Feininger, too, had studied. But it was Grosz's meeting with Jules Pascin in Paris that brought about decisive changes in Grosz's drawings. These new impulses were not so much thematic as technical. Pascin already had developed the shaky line and soft washes that characterized Grosz's sketches up to the beginning of World War I.

The Murder Motif

Grosz's subject matter still drew on his early interest in circus and dance hall artistes, melodramatic incidents, and sensational murders. His representations of artistes betrayed an erotic element. "The heavy-hipped and corsetted artistes typical of this period exerted a mysteriously compelling charm. The fashions of that era completely hid the female figure, but here the entire fleshly glory could be admired with the aid of opera glasses. Those heavy-thighed legs in silken tights played a prominent role in my fantasies" (Grosz). Orgies, adulteries (Illus. 4), scenes in boudoirs, bordellos and ladies' bars were frequent themes in Grosz's work at this time.

The pleasures of intimacy turned into aggression. Sex murder became a dominant motif. Grosz turned to various sources for his subjects. *Double Murder in the Rue Morgue,* 1913 (Illus. 5), was based on Poe. Other drawings were based on dime novels. When Grosz published his "Jugenderinnerungen" [Recollections of my youth] in 1929, he included with them a copy of an illustration from *Jack der geheimnisvolle Medchenmörder* [Jack the ripper], a dime novel he had kept from earlier years. Still others were based on

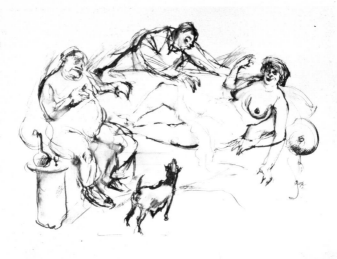

4 *Adultery,* 1913

actual or fictitious events in Berlin: *The Mielzynski Affair,* 1912–13; *Sex Murder on Ackerstrasse,* 1916 (Illus. 26).

The formal influence the dime novel illustrations had on Grosz is unmistakable. The extravagant gestures; the large, lunging steps of the figures, suggestive of a dramatic climax; the narrow focus of the scene; and the hectic movements all were basic elements in the oversimplified illustrations that appeared in pulp novels such as the Sherlock Holmes series *Aus den Gehelmakten des Welt-Detektivs* [From the secret files of the world's greatest detective] and *Nick Carter: Amerikas grosser Detektiv* [Nick Carter: America's greatest detective]. These illustrations inevitably depicted the high point of the action, a situation that seems utterly hopeless for the hero. In Grosz's work, the focus was on the crime itself. The victim, usually female, was shown lying there, having been dispatched by a hatchet or pistol.

The bloodthirsty quality of the pulp illustrations also was present in Grosz. In the drawing *When it was all over, they played cards* (Illus. 25), Grosz showed human limbs chopped off with a knife, a

5 *Double Murder in the Rue Morgue*, 1913

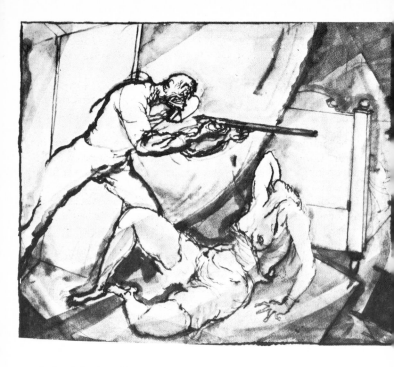

6 *Sex Murder*, 1912–13

straight razor and a hatchet and stuffed into boxes. In his autobiography, Grosz still could recall in some detail the German Sherlock Holmes story in which a butcher killed people and made sausages out of them, *Der Madchenmörder von Boston* [The sex killer of Boston], vol. 42, 1907.

The macabre quality of this Wilhelminian literature was intensified all the more when Grosz—no doubt influenced by the writings of Gustav Meyrink, which he admired very much—picked up the Frankenstein motif and incorporated it into his drawing *Homunculus* (Illus. 7) in 1912. The picture showed a grotesquely misshapen human figure being created out of severed body parts. The apparent cynicism of these drawings was in fact a kind of bitter satire.

Other drawings from this same period brought fictitious literary horrors back into the realm of reality. *The End of the Road* (Illus. 8), a drawing made in 1913, showed a woman hanging by the neck in a lower-middle-class apartment, her husband and baby dead at her feet. Death was shown, in concrete pictorial terms, as the only option for people who see no other way out. Here we find a kind of realism that links causes and effects and that is completely foreign to the murder scenes.

The murder drawings were cheap, sensational fairy tales of horror. They served as safety valves to release the pressure being built up in a militaristic state that had been preparing for war for a long time and that had imposed a rigid discipline on all its citizens. "It was clear that the sword of the state did not tolerate discussion in any form. That sword hung invisibly above us all. It had simply replaced the teacher's rod" (Grosz). Grosz responded to the limitations that the Prussian and Wilhelminian state placed on the collective by seeking individual refuge in the abnormal. In the society of that period, crime and open eroticism fell under that category. In this sense, Grosz's drawings signaled both the decline of Wilhelminian morality and the artist's personal liberation from the confinements imposed on him by society. We are not reading unintended meanings into Grosz's portrayals of horror if we see them as bold acts of individual rebellion. Grosz identified with the murderer, that is, with the figure who violates the law. A little later, all the brutality of a technological war would become reality. Mass murder would be sanctioned by the state.

Grosz's drawings of murders introduced a new motif into the visual arts. Before, murder had appeared only in a historical guise. Here, it was an actual, contemporary event. But the link with reality was a metaphorical one. On the one hand, these drawings represented a rebellion against state-imposed discipline. On the other, they anticipated the mass murder to come. The pictorial means Grosz used were those of cheap commercial art, and they originated in the longings and escapism promoted by the bourgeois entertainment industry.

Once war broke out, artistic impulses underwent a major change not only for Grosz but also for others. He did not use cheap literature as his point of departure but turned instead to the actual experience of mass annihilation in war.

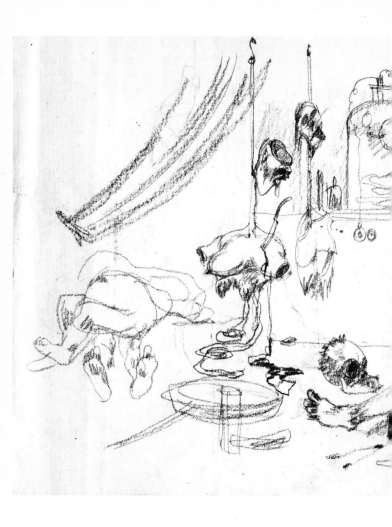

7 *Homunculus,* 1912

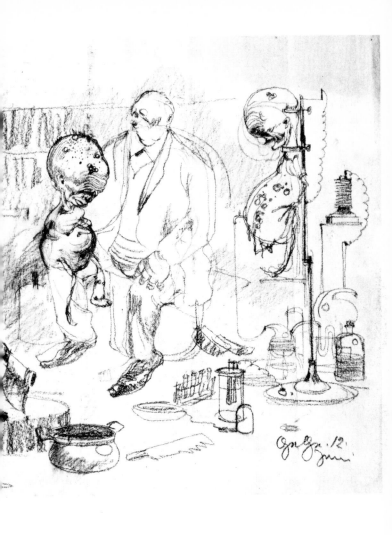

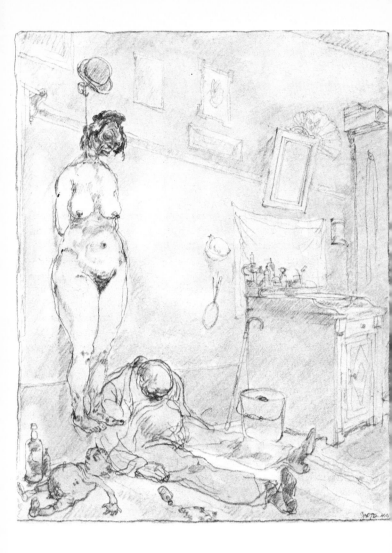

8 *The End of the Road,* 1913

War (1914–18)

Military Service and Its Emotional Impact

"To arms! Any sign of indecision or hesitation would be a betrayal of the fatherland. Our country's very existence is threatened. German power, Germany's very being is at stake." On August 6, 1914, after the Reichstag unanimously approved the necessary war loans, Kaiser Wilhelm II spoke these words to summon his people to war. The masses responded with unprecedented enthusiasm.

Although Grosz had, as he himself said, "grown up apolitical but in some kind of humanistic spirit," he still volunteered for service on November 11, 1914. Heinrich Vogeler enlisted voluntarily, too. But Grosz was by no means as enthusiastic about the prospect as were such artists as Marc and Macke. On May 11, 1915, he was discharged for reasons of health and declared "unfit for service."[8] In that same year he said in a letter: "The time I spent under the yoke of militarism was one of constant resistance, and everything I did during that time inspired the most profound revulsion in me."[9] One year of war made Grosz an eternal enemy of the military and of militarism.

Back in Berlin, Grosz wrote: "Life now is horribly drab, especially with food so short that you leave the table satisfied only on rare occasions. All portions in the restaurants are twice as small as usual." This letter went on: "I don't consider it exactly romantic on my part, either, that the adolescent idea of emigrating to the triumphant land of America and wallowing in its billions occupies my thoughts more and more these days. The artist Pascin is already in New York. . . . Having experienced one year of war, I'm no longer such a devoted friend of my fatherland."[10]

On January 4, 1917, Grosz was recalled to military duty. Two months later he wrote, "My nerves went to pieces this time before I

10 *The Grenade*, 1915

◁ 9 *Street Fight*, 1914

11 *Prisoners,* 1915

12 *General,* ca. 1916

even saw the front, the rotting corpses, and the barbed wire. . . . My nerves down to their last fiber reacted with abhorrence and revulsion!"[11] On January 5, 1917, Grosz was sent to a military hospital in Guben. From there, he wrote to his friend Otto Schmalhausen on January 18, 1917:

> everything around me is dark, and time flutters by black as the grave. Dear Schm., I am, God knows, not cheerful anymore. My misanthropy has assumed immense proportions. . . . I have the feeling that I'm gradually succumbing to depression. . . . I'm going through pure hell. The jagged sky looks white through the windows, white as a skull, but I never saw any stars in the sky. All I feel is a yearning for warm sand on the seashore, but over the beds hover black birds, the fever charts of the sick animals lying there. The last traces of humanity faded from their faces long ago, those yellow evil faces or the red ones tinged with deadly plagues. Death staggers and rattles melodically between the swinish beds. . . . Write to me. I'm totally isolated here. Your deceased G.

At the end of February, Grosz was transferred to the mental hospital Görden near Brandenburg. Franz Jung and Johannes Baader, who later would become champions of Dadaism, were put in mental hospitals at this time, too, as were Ernst Ludwig Kirchner, Otto Pankok and Heinrich Vogeler. The mental hospital was a route these individuals could take to escape legal prosecution for their provocative rebellions against the war and the ruling powers behind it.

Grosz's reaction was an individual one, too, not just a political one. The language of his letters had an Expressionistic quality that seemed lyrical and unrealistic but rose from profound feeling and concern.

On April 27, Grosz was sent home from the hospital; and a month later he was "discharged from the army as permanently unfit for service."[12] He returned to Berlin. The war channeled his pessimism ("I am firmly convinced that this epoch is gliding downhill toward destruction"[13]) and his misanthropy ("Everything I saw of people filled me with disgust and revulsion"[14]) into a clear direction: "My hatred was concentrated on the people who wanted to force me to go to war. I saw the war as a monstrously degenerate manifestation of the ordinary struggle for possessions. I had already come to despise this struggle in its minor manifestations. On this massive scale, it was unbearable."[15]

Drawings Inspired by Hatred

The war shook the world to its foundations. Values and ethical norms underwent total revision. At the beginning of the war, Grosz did not yet understand the mechanisms that made the individual a helpless victim of the governments' lust for power. But he began to see that as an artist and intellectual in a world gone mad, there could be no refuge for him in any vague aestheticism. It seemed crucial now, once and for all, "to put an end to those vapid French traditions that have almost completely dominated all painters, to turn away from insipid, sentimental painters, the Cézannes, the Picassos, etc." Art should not be mere entertainment anymore; it should take on a probing, oppositional character. "Harshness, brutality, clarity that hurt. There's enough music to go to sleep by."

He became aware that there were others who shared his feelings. "I began to realize that there were better things to do than work only for oneself and the art dealers. I wanted to be an illustrator. High art didn't interest me if all it did was present what was beautiful in the world. What did interest me was the work of the much-scorned social painters and moralists like Hogarth, Goya, and Daumier." And "Call it un-art if you will. Art spelled with a capital 'A' doesn't interest me."[16]

Grosz's political position during the war is not entirely clear. He met Wieland Herzfelde at Ludwig Meidner's in 1915. Like Johannes R. Becher, Gustav Landauer, Walter Benjamin, Franz Jung, and many others, he frequented the Café des Westens in Berlin where he may well have come into contact with revolutionary ideas. In 1915, he began publishing his work in Franz Pfemfert's radically pacifist periodical *Die Aktion* [Action]. But these contacts did not help him articulate a political position at this time. He heard talk of revolutionary movements but initially regarded them with skepticism. "The hopes for peace and revolution that some of my friends harbored struck me as unfounded."[17]

"One of my dreams (believe it or not!) is that changes and uprisings may take place after all. Perhaps someday, international socialism, which has become so spineless, may regain enough strength to stage an open rebellion. Then watch out Kaiser Wilhelm and your crown prince! This is no more than a fantasy. In the meantime, they keep issuing draft notices. Off to the slaughter-

13 *Sticking It Out*, 1915

house with you!"[18] Revolution was no more than a dream in Grosz's mind. He realized that the people who suffered directly from war and exploitation would have to be the movng force behind a revolution, not artists and intellectuals like him. "I know that only the hungry and the dissatisfied can put new ideas into action."[19]

In any case, Grosz's work at this time was not politically motivated. What impelled him was a boundless misanthropy rooted in aesthetic considerations. This point is of great importance in judging his works of social satire in the 1920s.

> Day by day, my hatred of the Germans is fueled anew by the hopelessly ugly, unaesthetic (yes, unaesthetic), and awful appearance of Germany's most German citizens. To put it as bluntly a I can: 'I feel no kinship with this human mishmash. . .' All I see around me, now that there are no more foreigners living in Germany, are fat, sloppy, deformed, ugly men and women (the women especially), degenerate figures (although a fat, red-faced, flabby specimen is declared 'a fine figure of a man') with poisoned vital fluids (too much beer), with hips that are too heavy and short. In a word, in recalling so much ugliness, it is hard to remain within the bounds of decency when one begins to draw.[20]

This misanthropic view, derived from aesthetic reactions, was the spark for Grosz's artistic work. "I drew and painted out of protest and tried, through my work, to convince my audience that this world was ugly, sick, and hypocritical."[21]

Some drawings from this period (1916–18) continued to focus on the circus, the music hall, murder and crime. Others depicted war and urban life. Grosz used a number of different stylistic devices in them. These drawings, like Grosz's verbal statements, were more accusatory than combative in character. Like his work before the war, they had a compensatory function. They articulated hatred and rage. "My 'art' was a kind of safety valve for me at that time, a valve that let off the hot steam that accumulated in me. Whenever I had time, I gave vent to my anger by drawing. In notebooks and on letter paper, I sketched everything in my surroundings that offended me." Grosz was trying "to capture the ridiculous and grotesque aspects of a world swarming with busy little ants bent on death."[22]

At first, the war drawings showed Expressionistic landscapes dotted with lifeless forms. But this rigidity and lack of empathy soon evolved into felt presentations of suffering on the battlefield.

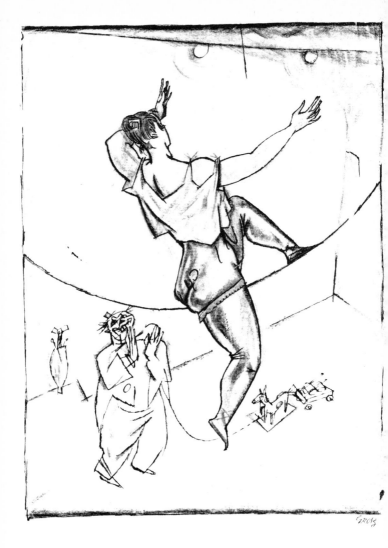

14 *Tightrope Walker,* ca. 1916

15 *Riot of Madmen,* 1915 ▷

Formally, they showed the strong influence of Meidner. Still other drawings depicted the misery of prisoners of war.

In the drawings of urban life (streets, elevated trains, cafés), two major themes typical of Grosz's work dominated in this period. One was a hatred of everything that had to do with war. For him, this included not only the bemedaled officers and the elegantly dressed war profiteers but also the masses who lined up eagerly to participate in this mass murder. The other was a fascination with the city and the wide range of experience it offered.

Urban Motifs

The city struck Grosz as a *Riot of Madmen* (Illus. 15): Murders and beatings, rapes and suicides were the rule in his chaotic urban landscape. He also saw it as *Pandemonium* (Illus. 16), rampant with fatal traffic accidents, fires, drunkenness, rebellion, greed, theft, prison breaks. These drawings swarmed with small figures simply depicted in line sketches. The figures and the buildings teetered out of balance.

The objects shown in the drawings were placed over and behind each other in a two-dimensional scheme that made no attempt to show perspective. The rapidly executed figures and objects resembled doodlings, and they often were layered in a kind of network that created a graffiti-like impression. In fact, Grosz was inspired by graffiti. Searching for new pictorial possibilities that would stand in contrast to traditional ideas of beauty in art and give expression to his misanthropic attitude, and hoping "to achieve a style that would present the harshness and ugliness of my material in drastic and unembellished form, I studied the most primitive manifestations of the artistic impulse. I copied the folk drawings I found in public toilets. They struck me as the most direct possible expression of strong feelings." Children's drawings stimulated his work, too. "I gradually developed the razor-sharp style I needed to record observations made by a totally misanthropic eye."[23]

16 *Pandemonium,* 1915–16 ▷

Grosz confessed that he had "little interest in the big exhibits devoted primarily to 'pure art.' " He was more drawn to "those artists who worked to supply the daily need: the illustrators, the advertising artists, and the journalistic cartoonists."[24] He was able to define his ideas on the function of art more clearly now. He wrote in a poem that an artist could no longer "just doze in his poet's armchair or stand at an easel, painting little pictures in pretty shades."

> It's up to us to rouse the complacent artist folk
> from their after-dinner naps,
> to tickle their pacifistic bums.
> Rumble, explode, blow up!—or hang yourselves
> from the window casement. . . .
> Let your corpses dangle out in a pub-lined alley!
> Yes! Get back your agility, bounce
> to left and right—get flexible—strike out! Uppercut
> or a right hook to the heart![25]

In rejecting tradition, Grosz again committed an act of artistic rebellion. By choosing a simple and direct drawing style—no doubt he was influenced in this by the German Expressionists' high regard for primitive art—he swept aside conventional painting in the "high style" and at the same time cleared the way for new possibilities of artistic expression. His sharp, unmerciful attack made any enjoyment of "beauty" impossible. Grosz forced the observer to open his eyes and experience the same confusion from which Grosz himself was suffering at this time. His drawings no longer reflected a sarcastic delight in trivial materials. (The only things these works shared with popular pulp art were some stylistic features.) What they did in fact reflect now, was Grosz's irritated response to a destroyed world. This destruction became evident first and most blatantly in the city. By piling horrors upon horrors in his pictures, Grosz made everyday crime symbolize the vast crime of war. War may be fought at the front, but its principles become evident in the lives of individual people.

Before the war, it was the odd and abnormal that fascinated him and seemed to offer him an escape from the rigid norms of society. Now, his work was dominated by a sense of succumbing completely to the collapse of the society around him and of having no personal prospects of escaping or effecting change.

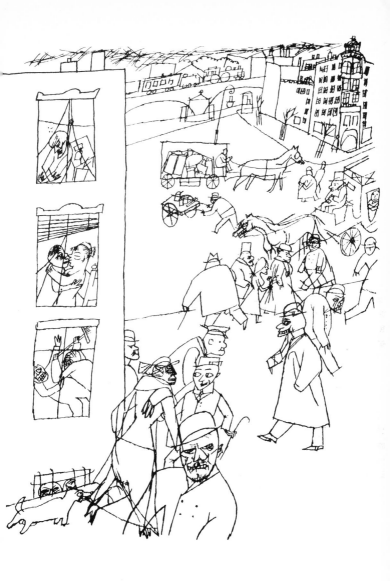

17 *Roads Men Take*, 1915

The drawing *Street Scene with Artist* (Illus. 18) expressed this relationship to the world in almost symbolic form. Perplexed and unsure of himself, the artist sits in the midst of a chaos he cannot bring under artistic control. The sheet of paper in front of him remains empty. Grosz struggled to fill that emptiness. In rapidly executed series of sketches, he sharply and mercilessly attacked the world he saw, trying to capture its decay and the forces at work in it.

He was particularly interested in the contradictions inherent in that world. Figures representative of those contradictions appear in a café (*Café,* 1914—Illus. 19): the old men with their dueling scars and stiff collars; the lady with a veil and a transparent dress; a man with a fur-lined coat, a walking stick, and a jaunty hat; the gossiping petit bourgeois; the war cripple wearing medals that are supposed to compensate him for his wounds; an officer smoking a cigar and seated with a matron holding a little purse. A band is ensconced at the top of the drawing, entertaining the war victims and the entrepreneurs, the coquettes and the financiers alike.

In his differentiated portrayals of classes, Grosz revealed the interest groups within the society, but he had not yet openly taken sides. He was trying to gain a clearer understanding of reality by observing it constantly and translating it into pictorial form.

The war was still going on. The war profiteers were flourishing while the great majority of the people were suffering hunger and death. Richard Huelsenbeck described Berlin as he found it when he moved there from Zurich in 1917.

> Berlin presented a gloomy visage. The people there had just survived a winter when the bakers had nearly had to resort to baking bread out of straw. The turnip was the focus of interest in Germany. It was obliged to do duty as cake, roast hare, and malt beer. There was fierce activity on the black market, and moral scruples fell right and left. . . . Types with deformed heads and caved-in chests, people suffering from mental and physical rickets won the upper hand. . . . And all this time, the official hocus-pocus of war went on. Military trains carried loads of fresh meat, human and porcine, to the front; and that great hypocrite and criminal Guillaume II kept making speeches to his people. It was a time of passive resistance, of budding doubt on the validity of patriotism and the monarchy, a time of irritability that threatened to break out in fist fights, a time when the air was oppressively thick, a time of misery.[26]

18 *Street Scene with Artist,* ca. 1917 ▷

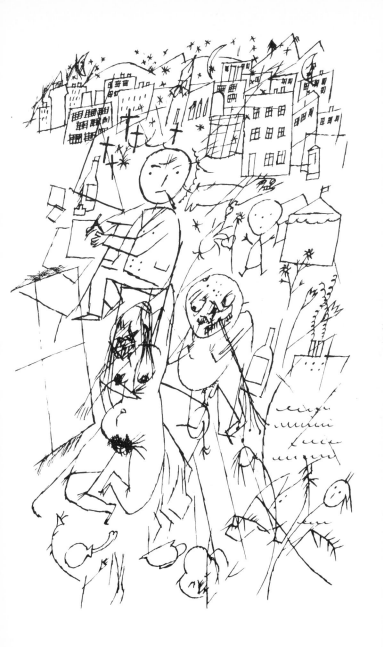

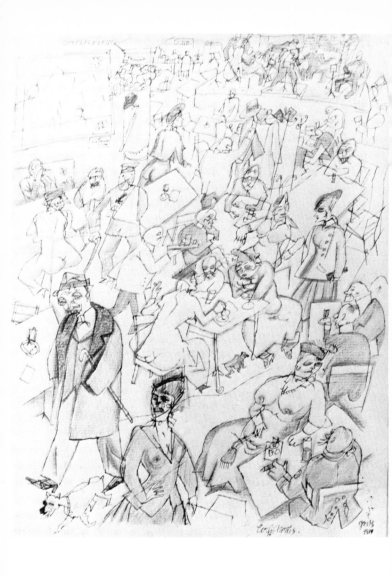

19 *Café,* 1914

There was still another component in Grosz's relationship to the city. It had its origins in his childhood, but only now did it begin to make itself felt in his work. For a nine-year-old boy, Nick Carter, Leatherstocking and Old Shatterhand symbolized a country where adventure and freedom, not school and military service, were the rule. Leatherstocking "was the first bit of America that I took to my heart." For Grosz as a boy, America was a "free" country. "That's where you went if life at home became too confining, if you didn't want to do two or three years of military service, if you were the eleventh or thirteenth son in your family." The reason for emigrating often was simply "to get away from a petty, provincial way of life, away from the eternal bureaucracy and government paternalism that we Germans have lived with for hundreds of years and are still living with" (Grosz).

Such words as "efficiency," "advertising," "service," "keep smiling" and the name Ford were magic formulas for the young Grosz. American westerns were his favorite films.

Now, during the war, this attraction that America held for him came alive again. His condemnation of the war inspired disgust for everything German and increased his longing for a completely different world. As far as Grosz was concerned, such a world already existed on the other side of the Atlantic. He did not think that world could be created merely by changing his immediate surroundings to conform to his ideals.

Grosz shared the version of the American dream that enjoyed wide circulation at that time, a dream of adventure, freedom, and success as portrayed in pulp literature. When Brecht and Feuchtwanger wrote about America a few years later, they were primarily concerned with the postwar situation and the great economic evils that a highly capitalistic society had made possible there. Brecht and Feuchtwanger attacked America. Grosz admired it.

In his dress, posture, and language, Grosz played the American. Wieland Herzfelde recalled visiting Grosz in his studio once and finding there a photograph with the (obviously fake) inscription: "For my dear old friend Chingachgook, devotedly, from Thomas

A. Edison." Chingachgook, a figure from Cooper's Leatherstocking tales, reappears in the title of a lithograph (*Texas Scene for My Friend Chingachgook*—Illus. 21) that appeared as part of the *Erste George Grosz-Mappe* [First George Grosz portfolio] in the spring of 1917. The first picture in this portfolio was called *Reminiscence of New York* (Illus. 20). When Herzfelde asked him at the time if he had ever been in New York, Grosz said he had.[27]

Walter Mehring recalled a visit when Grosz pretended "the shores of the Hudson, the Battery, the Fishmarket, and Hoboken were his native haunts, even though he had never been in any of those places."[28] Paul Westheim also reported that Grosz was "wildly infatuated with America." "I have to admit that the greater part of my knowledge of America—or rather my knowledge of 'how the Americans do things,' such as taking pictures, boxing, filling their pipes, singing, looking at prints, or organizing gala art shows—all of that I learned from George Grosz who was always willing and eager to pass on such information to me. Grosz created the impression—at that time, at any rate—that he considered it a congenital defect to have been born near Hallesches Tor [in Berlin] and not in a forty-seventh story apartment on 16th Street."[29]

It was in this period that Grosz changed his first name from Georg to George. In protest against the German propaganda campaigns against England, Helmut Herzfeld called himself John Heartfield; but Grosz's anglicizing of his name clearly came from his passion for America, which also contained, of course, an implicit rejection of the German mentality. Grosz gave tangible expression to his concept of America in the drawings *Reminiscence of New York* (Illus. 20), *Old Jimmy,* and *The Gold Prospector* (Illus. 22). All of these drawings were done in 1916, and all of them combined urban mythology with shorthand symbols of the life of adventure. Colt revolvers, whiskey, horses, burnings at the stake, gin, chewing gum ads, blackjacks and English words all were part of this pictorial arsenal.

20 *Reminiscence of New York*, 1916

21 *Texas Scene for My Friend Chingachgook,* 1916

Poems: Civilization as Chaos

In this period Grosz wrote a number of poems. Some of them were published in the periodical *Neue Jugend* [New youth] from 1916 on, and Grosz also read them in public when he appeared at readings in Berlin, Dresden, Munich, and Mannheim with Johannes R. Becher, Theodor Däubler, Wieland Herzfelde and Else Lasker-Schüler. In these poems, the dialectical relationship between Grosz's enthusiasm for a mythical American civilization and his rebellion against civilization as chaos became clear. These poems usually were about subjects Grosz also had presented in his drawings.

New York

99 degrees! Wanamaker's! Madison Square Garden!
People look like steamed hotdogs in this cauldron—dripping wet!!
Towering department stores keep spewing people into the streets.
The people stink and sweat.
99 degrees!
The air is dank, warm, and oily, like in a huge turbine hall.
Red bones rise out of the earth somewhere,
All of iron and steel, towering high—
—Signs grin, letters dance
Blue, red—Bethlehem Steel Works—
Way up there, like bird houses, hang
Finished floors, tiny people, cranes.
In fishnets of steel
Fast el trains thunder and howl in rut.
Newspapers explode out of cars—
And on 28th Street a girl
Wild with the heat jumps from the tenth floor.
—99 degrees—
Everything wilts, seethes, hisses, roars, clatters, blats, toots, whistles,
 glows, sweats, pukes, and works.[30]

In a retrospective of 1921, the magazine *Die Weltbühne* [The world stage] recalled one of Grosz's Berlin appearances in the poetry readings held in 1917. He was, the magazine said, a "cowboy who has read Stendhal" and an "American Wedekind." "He shocked not only the bourgeois but the bohemian as well." *Die Weltbühne* quoted these lines as a sample of his work:

I shoot my revolver
first thing in the morning when I step out of my cabin
broad-shouldered, tanned brown and wearing a red shirt—
the dog is barking furiously—
and the parrot sings in English.
Ha!! I feel alive! Early morning! Dew all over the grass,
my two revolvers, my huge hunting knife,
my shaggy black dog—[sic] oh!! Colorado!
Freedom!!![31]

The short sentences, the exclamations and the emotionally charged
vocabulary reflected the Expressionist character of these poems.
The flow of intoxicated language often was broken by banal
interjections.

The Gold Prospector's Song

The engineers line up,
And cranes, steam, song,
and the factories red,
And are those planes up there far above the red of the day?
Express trains cut through the landscape,
hurtling!
From San Francisco to New York---[sic]
Everything!!!
The international white slave trade.
International conflicts. Wars.
The department stores and whore houses
in Rio-----[sic]
You brown-skinned prostitutes,
Penang—Cochinchina, Algiers, Marseille
Look! Steamers lie ready,
smoking.
Gold! Gold! Gold!!!
Move, you prospectors!
Get going!
The Klondike calls again!!!
Hang onto your knives and spades—
The engineers are lining up already,
Black magicians in American sports jackets.
America!!! The future!!!
Engineer and businessman!

Steamships and express trains!
But above my eyes
arch huge bridges
And the smoke from a hundred cranes.[32]

In another poem, Grosz introduced himself into the staccato language of his collage.

Song to the World

Oh, gaudy world, you Coney Island,
You blissful freak show,
Watch out! Here comes Grosz,
the saddest man in Europe,
"A Mournful Phenomenon."
His stiff hat pushed back on his head,
No Slouch He!!!!
Nigger songs in his head,
Colorful as fields of hyacinth,
Or rushing express trains,
Rattling over humming bridges—
Ragtime dancer
Waiting with the crowd at the picket fence
For the Rob. E. Lee.
Horido!
By the beard of Headmaster Wotan—
In the afternoon, disguised sewers,
Rot painted over,
Perfumed stench—
Grosz can smell it.
Parbleu? It stinks of roasted children here.[33]

In his 1927 review of Brecht's *Hauspostille* [Domestic breviary], Kurt Tucholsky pointed out that Brecht's poem "Vom armen B.B." [Of poor B. B.] showed a certain similarity to Grosz's early poems.[34] And despite the differences in diction, there was indeed a similarity not only in the use of anglicisms but also in the presence of an individual, lyrical consciousness confronted with a self-destructive civilization.

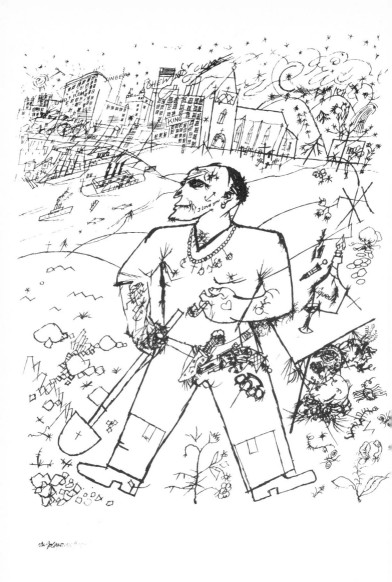

22 *The Gold Prospector*, 1916

23 *Detective Story*, 1918

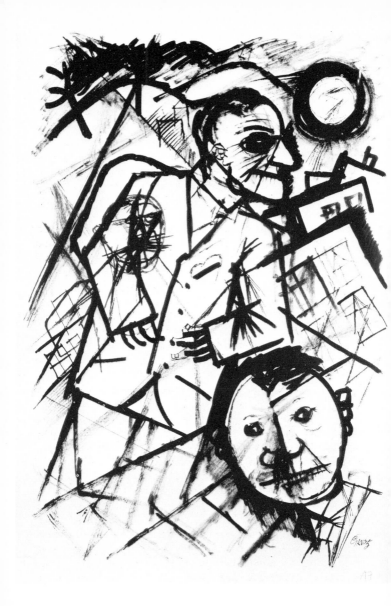

24 *At Night*, 1917

The writers and artists who gathered in the Café des Westens in Berlin agreed they had to do something against the war, but they lacked any concrete plans. Inspired in part by George Grosz, whom he had met in 1915, the young writer Wieland Herzfelde, the brother of John Heartfield and the son of the socialistic writer Franz Held, decided to found a magazine. He felt there was a particular need for the publication he had in mind because the only militantly anti-war periodical, Pfemfert's *Die Aktion* [Action], was being subjected to such strict censorship.

Wieland Herzfelde was able to take over the *Neue Jugend* [New youth], a publication that had been appearing since 1914, and reshape its editorial policy. The new policy was "to stand up for all those who are running into opposition from and being misunderstood by the public." "It is high time that all intellectuals stand together against their enemies."[35] The first issue appeared in June 1916 and contained contributions by Albert Ehrenstein, Richard Huelsenbeck, Else Lasker-Schüler, Franz Held, Wieland Herzfelde, Gustav Landauer, and Theodor Däubler. The lead contribution was Johannes R. Becher's poem "To Peace," and the issue also contained two drawings by Grosz.

Neither in this issue nor in the following ones was there any evidence of a clear-cut political position. Herzfelde himself would speak later of an "opposition decorous both in form and tone." In a quality format, he published mainly lyrics that expressed only vague opposition to the status quo and never overstepped the limits of aesthetic Expressionism. There was not a trace of the radicalization that would later prompt Becher, Grosz, Herzfelde and Landauer to join the Spartacus movement.

Grosz continued to publish poems and drawings regularly in the *Neue Jugend,* and he also became known through an article on him by Theodor Däubler in *Die weissen Blätter* [The white pages] in 1916. In August of that year, the *Neue Jugend* ran an ad announcing a *George Grosz-Mappe* [George Grosz portfolio], which, in the next issue, was called the *Erste George Grosz-Mappe* [First George Grosz portfolio].

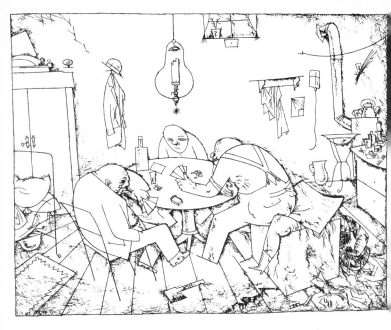

25 *When it was all over, they played cards,* 1917

The portfolio appeared in the spring of 1917 (cf. Illus. 20, 21). It contained nine lithographs, mainly on urban themes. Most of the drawings from which the lithographs were made already had appeared in conjunction with Däubler's article on Grosz in *Die weissen Blätter.* According to an ad in the *Neue Jugend* (February/March 1917), a copy of the portfolio in the normal trade edition cost twenty marks. The edition consisted of 120 copies.

In this same year, the style of the *Neue Jugend* changed dramatically after Wieland Herzfelde was drafted and Grosz and

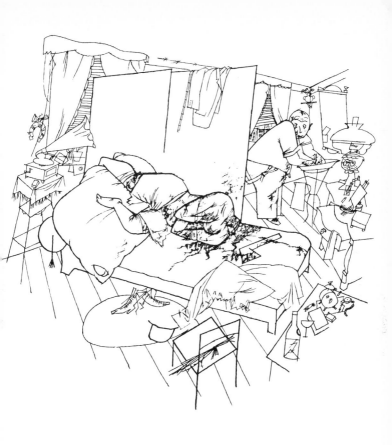

26 *Sex Murder on Ackerstrasse*, 1916

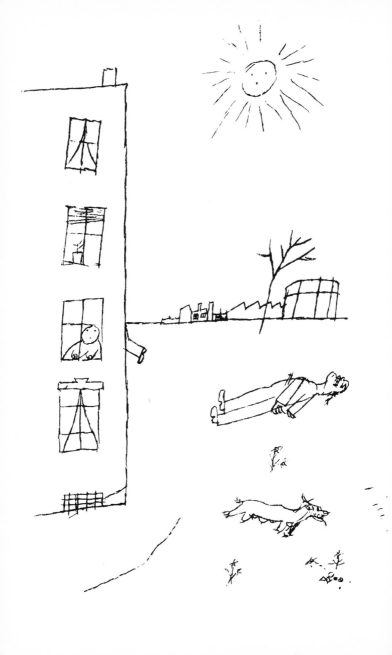

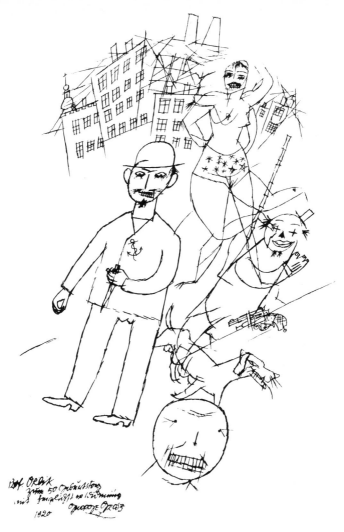

28 *Street Scene*, ca. 1917

◁ 27 *Murderer*, 1917

Heartfield assumed the major editorial responsibility for the magazine. Starting with the issue of May 1, 1917, the magazine presented itself as a weekly in newspaper format. A more open typography, a more aggressive tone, and a major article by Richard Huelsenbeck ("Der neue Mensch" [The new man]) marked the arrival of Dada. The names of the writer Franz Jung and the critic Max Herrmann-Neisse had been added to the editorial staff, and there was an ad announcing a *Kleine Grosz-Mappe* [Small Grosz portfolio].

In the meantime, Wieland Herzfelde had started his own publishing house, the Malik-Verlag, which would publish both the *Neue Jugend* and the Grosz portfolios. The June issue of the magazine was primarily a prospectus for the *Kleine Grosz-Mappe* [Small Grosz portfolio]. It contained some political notices, but its main features were some poems by Grosz ("You've got to be a man made out of rubber" and "Can you ride a bike?"), some photographs of New York, and ads for the *Kleine Grosz-Mappe* [Small Grosz portfolio] as well as for some readings sponsored by the *Neue Jugend*. Grosz also wrote the reviews of variety shows scattered through the issue. The typography made use of different typefaces and old stereotype plates mixed together in a collage-like fashion. The ad John Heartfield did for the Grosz portfolio appeared on the last page of the June issue and was one of the first Berlin collages done in Dadaistic style.

The *Kleine Grosz-Mappe* [Small Grosz portfolio] appeared in the fall of 1917. It consisted of twenty lithographs as well as some poems by Grosz and a title page by Heartfield. An edition of 120 copies was printed. Here, too, scenes of city and café life made up the major part of the portfolio. As in Grosz's poems, the principle of composition was a lyrical, associative one that made figures and buildings teeter out of balance. Figures and objects were piled on top of each other on the pictorial surface, and Grosz used a graffiti-like drawing style that made objects appear to be transparent. Grosz often modulated the rapid, sketchy quality of the figures into distorted caricature that expressed his scorn for the petite bourgeoisie.

The principle of drawing to make figures appear transparent had an ideological purpose: What you see through is unmasked. Grosz considered it his job to reveal the true but hidden faces of those who

29 *Contrasts*, 1917

trotted along obediently and even now refused to rebel against the kaiser and his war.

It should be pointed out once again that Grosz, as he himself often emphasized, had no faith whatsoever in the masses, whom he regarded as limited and spineless. Heartfield and Herzfelde, who became his close friends during this period, pinned their hopes on the revolutionary power of the underprivileged classes. This optimistic view determined their political position and motivated them to work for the Communist cause for the rest of their lives. Grosz, on the other hand, shared the rather vague skepticism of many politically rootless intellectuals. His pessimism would not let him believe that man and society could ever undergo radical change. This was true in any case for the period up to the revolution of 1918–19. But even then Grosz's position remained equivocal, and he never served any cause wholeheartedly.

The *Doppelgänger* Motif

During the war, Grosz wrote in a letter to his friend Robert Bell: "I am incredibly isolated, that is to say, I'm alone with my doubles: phantom figures into which I project certain dreams, ideas, inclinations, etc. I tear, so to speak, three personae out of my inner fantasy life, and I myself believe that these pseudonymous figures really exist. —Three firmly delineated types have gradually emerged. 1. Grosz. 2. Count Ehrenfried, a nonchalant aristocrat with manicured fingernails, a man intent on nothing but cultivation of the self; in short, an aristocratic individualist. 3. the physician Dr. William King Thomas—he represents the more practical, materialistic, American side in the primal nature of Grosz."[36]

This *doppelgänger* motif played a decisive role in Grosz's later life and work. It was especially prominent during the war. Grosz signed his reviews, letters, and drawings as Count Ehrenfried, as Edgar A. Hussler from Boston, as Lord Hatton Dixon and as Dr. William King Thomas. His contemporaries mentioned time and again that Grosz—even in the period of his greatest political activity—dressed and behaved like a dandy. When he sold his first drawing to *Ulk* in 1910 he spent the money on a pair of "wonderfully contoured patent leather shoes from America" (Grosz).

30 *Tragedy,* 1917

Grosz's petit bourgeois background inspired his yearning for a different life, his yearning to leave his origins behind. His dandyism and his enthusiasm for America were the two personal escape routes he chose. But at the same time he still felt an allegiance to the world he came from and identified with the sufferings of the underprivileged classes. However, in this phase of his intellectual development, the proletariat still had no place. From the very outset, of course, he was a rebel who despised convention. But given Grosz's skepticism, this initial position could not produce any consistent political or artistic development. The search for an identity somewhere between affirmation and negation, the struggle to define the role of the artist and intellectual in a complex society, was characteristic of his work and of the work of many others as well.

Then, too, Grosz's cosmopolitan pose and his scorn for the man in the street perpetuated the myth of the artist as an outsider and bohemian. Once the unity of art and political power broke down, the artist found himself, in the course of the nineteenth century, driven more and more into the role of an outsider who stood on the fringes of society and attacked it from that position. This role shaped the artist's consciousness. As an outsider, he enjoyed a freedom of expression not granted to the normal citizen dependent on a job for survival. But at the same time, the artist needed the applause and approval of the middle-class world he attacked and despised. One result of this paradoxical situation was the total isolation of the artist. Another, which followed on the first, was the drawing together of artists in cliques to form a united front on behalf of the individual.

In Germany, the resolution of this paradox could occur only when an artist could work concretely for a partisan cause, when—in principle, at least—his social, political and artistic views coincided with each other enough to let the artist act consciously as a social creature, find new roots, and accept certain limitations on his artistic expression. One of the tasks we will have in the remainder of this study is to determine to what extent George Grosz continued to adhere to his individualistic bourgeois skepticism and to what extent he placed his art in the service of a political cause—and, by doing so, found the identity that would allow him to dispense with his phantom selves.

31 *Self-Portrait*, 1917

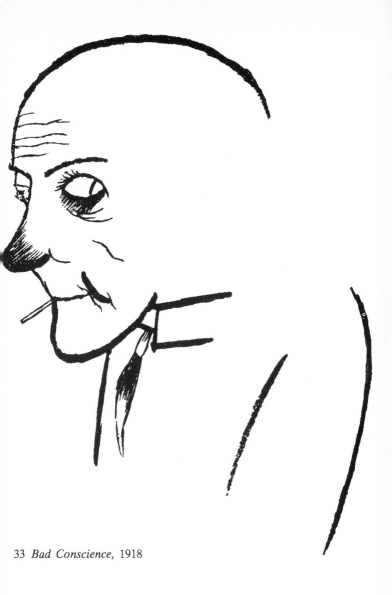

33 *Bad Conscience,* 1918

◁ 32 *Dead Serious,* 1918

34 Prospectus for the *Kleine Grosz-Mappe* [Small Grosz portfolio], 1917

Art and Revolution (1918–23)

Dada in Berlin (The Pre-Revolutionary Phase)

The Alsatian Hans Arp, the German Hugo Ball, the Rumanians Marcel Janco and Tristan Tzara—all of them emigrants—founded Dadaism in Zurich in 1916 as a form of protest against a war-mongering bourgeoisie that was undermining all cultural values. What they were trying to produce was "a kind of anti-cultural propaganda, motivated by honesty, disgust and profound revulsion for the affected sublimity of the intellectually fashionable bourgeois."[37] Bakunin's thesis—isolated from its context—that the art of destruction was a creative impulse served as a rallying cry for the Dadaists. The revolution was an aesthetic one. Arp and Max Ernst in Cologne, Schwitters in Hannover, and Paul Citroen, Theo van Doesburg and Otto van Rees in Holland all set about the business of revitalizing art.

In 1917, Huelsenbeck went to Berlin. The situation there was completely different from that in Switzerland. In Berlin, the scene was dominated by the war, social unrest, hunger, the increasing wealth of the few and the increasing poverty of the many. "It was therefore essential to adopt other more politically effective means than were appropriate in Zurich." "Dada in Berlin had a political character from the very outset."

Correct as this statement may be, it also has to be said that the pre-revolutionary phase of Dadaism in Berlin, under the guidance of Raoul Hausmann and Richard Huelsenbeck, engaged in cultural criticism but did not discuss art and literature in the context of social issues and conditions. In Huelsenbeck's view, for example, revolution could be an entertaining and enjoyable project: "The Dadaist revolution is inspired by joy in movement and springs from a surplus of energy."[38]

Hausmann and Huelsenbeck, along with Johannes Baader, George Grosz, John Heartfield, Wieland Herzfelde, Franz Jung,

Walter Mehring and Erwin Piscator, brought Dada to full bloom in Berlin. The ground had been prepared on the one hand by Herzfelde's *Neue Jugend* [New youth], which had adopted an even more radical line and style after it had been banned in April 1917, and on the other, by the magazine *Die freie Strasse* [The open road], founded by the writer and Spartacus sympathizer Franz Jung. Through Jung's and Huelsenbeck's influence on it, Herzfelde's *Neue Jugend* became, in the course of 1917, a rallying point for those writers and artists who felt themselves to be in opposition to society but who had not yet developed any real clarity on social and political issues. Like Grosz, Herzfelde and Huelsenbeck, they remained loyal to Expressionism, but they were nonetheless laying the foundations for Dadaism in Berlin.

Dada made its first public appearance in Berlin in January 1918 and its second in April. The second event featured, among others, Grosz reading his own poems, Hausmann with a talk on "Das neue Material in der Malerei" [New material in painting], and Huelsenbeck speaking on "Der Dadaismus in Leben und in der Kunst" [Dadaism in life and art]. The Berlin Dadaists also indulged in the same kinds of provocative behavior as their precursors in Zurich had. Grosz is reported to have done a pantomime of defecating in front of some paintings by Corinth. Together with Mehring, he staged an onomatopoetic contest between a sewing machine and a typewriter.

In this pre-revolutionary phase, the protest was directed primarily against the bourgeois art world and especially against Expressionism. The manifesto of the Berlin Dadaists, published in 1918 and signed by Tzara, Jung, Grosz, Janco, Huelsenbeck, Hausmann and others, began with a criticism of Expressionism. "Under the pretext of serving spiritual values, Expressionist writers and artists have flocked together in a clique that already is yearning to occupy a high place in the history of art and literature and lusting after the honors that bourgeois society can bestow. Under the pretext of furthering the life of the soul, they have sided against Naturalism and consequently adopted the abstractness and pathos that inevitably follow from a purposeless, comfortable, and stolid way of life."[39] Huelsenbeck claimed that Expressionism had degenerated into a mere fad "because, by its very nature, it promotes the retreat and bankruptcy of the German spirit." In

35 *The guilty party goes undetected,* 1919

Huelsenbeck's view, Expressionist art and thought had sold out to the "war machine" back in 1914.

The Dadaist, Huelsenbeck said, "instinctively sees it as his task to destroy the art ideology of a people" who regard culture as "Veronal for the conscience" and who "invoke Goethe and Schiller to justify this war to themselves and the rest of the world." He went on to say that the Dadaist will "use all available means of satire, spoof, irony and, if necessary, even violence, to attack this kind of culture. . . . It would be best to do this at large public events where, for an appropriate admission fee, the visitor can see everything that has to do with spirit, culture, and the soul symbolically demolished."[40]

Grosz later would call attention to the relationship between Dadaism and what was going on in society at large, but at the same time he emphasized how apolitical pre-revolutionary Dadaism was. "Dadaism was not an ideological movement. It was an organic product that emerged in reaction to the head-in-the-clouds tendencies of so-called sacred art, whose proponents were contemplating cubes and Gothic art while the field marshals went on painting in blood."[41] In a different context, Grosz wrote: "Dadaism represented a rejection of a narrow, arrogant, and overrated milieu, which, existing in a vacuum between the classes, assumed no responsibility for the life of the whole. This rejection was accompanied by irreverent whooping and derisive laughter. We realized at that point that we were looking at the insane end products of the existing society, and we burst out in laughter. What we did not see was that a system underlay this madness."[42]

But if we look past the rhetorical excesses of the "Dadaist Manifesto" of 1918, we see that it also formulated positive artistic goals that Grosz already had realized in the drawings he had done during the war. "The highest art will be an art that springs from a consciousness of the thousands of problems of our time, an art that is shattered in pieces by the explosions of recent weeks, an art that attempts to reassemble its scattered limbs again and again, always feeling the impact of the day just past. The best and most striking artists will be the ones who rescue, hour by hour, the shreds of their bodies from the chaotic upheavals of life, artists doggedly loyal to the intellect of their times, artists bleeding from their hands and hearts."[43]

36 *How the Court Should Look,* 1919 ▷

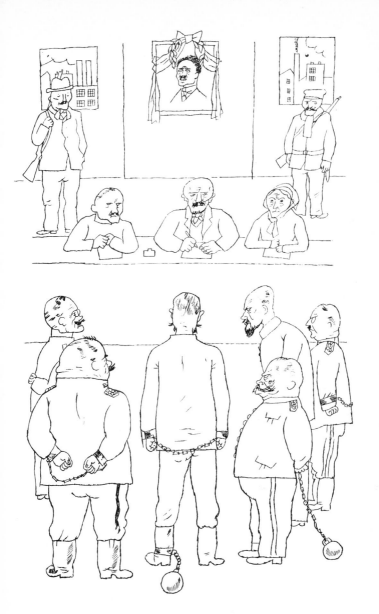

37 *Here's to Noske! The proletariat has been made harmless!*, 1919

Revolution and Counterrevolution

From 1915 on, there were increasing numbers of anti-war demonstrations in Berlin and in other cities. Further riots occurred in 1917 because of the inadequate food supplies. The Independent Social-Democratic Party of Germany *(Unabhängige Sozialdemokratische Partei Deutschlands*—USPD), which broke off from the Social-Democratic Party of Germany *(Sozialdemokratische Partei Deutschlands*—SPD), openly fought to bring the war to an end. In January 1918, 400,000 Berlin workers in the arms industry went on strike. They elected 400 deputies to a workers' soviet that called for immediate peace without any territorial annexations, for more food for the people, for an end to siege conditions and military supervision in the factories and for a democratization of the state. The soviet did not, however, demand socialism or the abolishment of the monarchy. Workers' soviets were formed in other cities, too. In late January and early February of 1918, 1.5 million workers were on strike.

When the navy was ordered out to engage in an utterly futile last stand, the sailors staged passive resistance at the end of October 1918. In early November, the sailors in Kiel took up armed resistance, and the workers and soldiers declared solidarity with them. They demanded an immediate end to the war, the release of political prisoners and general democratic suffrage. This movement of solidarity spread to other German cities. In Munich the king of Bavaria was forced to flee the country. Then the kaiser himself abdicated and fled.

In Berlin, Scheidemann of the SPD proclaimed the republic. A Council of the People's Deputies, made up of members of the SPD and the USPD, was formed under the leadership of Friedrich Ebert. There was also a revolutionary Executive Soviet of the Workers' and Soldiers' Soviets. The Council of the People's Deputies restored the command authority of the military. This step determined the form the new state would have. The decision between a soviet republic and a parliamentary democracy fell out against the soviet republic.

The Spartacus League, the left wing of the USPD, was founded by Rosa Luxemburg and Karl Liebknecht to promote revolutionary goals. The USPD decided to boycott the new government in protest

against the counterrevolutionary goals of the SPD. Gustav Noske (SPD) was placed in command of the counterrevolutionary forces. Early in January 1919, the newly founded Communist Party of Germany *(Kommunistische Partei Deutschlands*—KPD) staged the Spartacus uprising in Berlin. Within a week, government troops and volunteer units *(Freikorps)* under Noske put down this rebellion with great bloodshed. Rosa Luxemburg and Karl Liebknecht were assassinated. Noske's troops extended their reign of terror in response to continuing unrest and strikes. As late as March 1919, executions without trial were still the rule. Early in May, Noske crushed the soviet republic in Munich.

The SPD resorted to armed force to see to it that Germany's form of government would be a parliamentary democracy and not a soviet republic, and in doing so, it had no scruples about calling on the brutal *Freikorps* and on an army still dominated by the Wilhelminian spirit to do its dirty work. The national assembly in Weimar then established a bourgeois government headed by Friedrich Ebert.

Reparations, inflation, and widespread poverty created a climate of political instability. In 1920, two right-wing radicals—Kapp, a director general of the East Prussian agricultural credit banks, and General von Lüttwitz—taking advantage of this instability, attempted to overthrow the Weimar government and establish a military dictatorship. But a general strike called by the unions put an end to the Kapp *putsch.* Following the *putsch,* Noske's party forced him to give up his post as minister of the army, but the army still continued to suppress uprisings in Saxony and in the Ruhr with great brutality. The forces of reaction were on the road to power. In 1920, Hitler presented the National Socialists' 25-point program in Munich.

During this period, the liberal diplomat Count Harry Kessler kept a diary of particular interest to us here because it shows how profoundly intellectuals were affected by these revolutionary happenings and how incensed they were by the actions of the SPD. The following excerpts are taken from Kessler's diary.

> Berlin, January 14, 1919. . . . The old Social-Democratic party wants change only on the material level, e.g., a more just and efficient distribution of goods and improved social organization. It is not calling for anything new in the realm of ideas. Yet this is precisely what the

38 *The White General*, 1922

political innovators further to the left are crying for. This and only this can begin to justify the carnage of the World War. . . .

Berlin, January 15, 1919. The city is, so to speak, occupied by troops loyal to the government. Helmeted soldiers stand on every street corner, their bayonets mounted and their belts weighed down with hand grenades.

Berlin, January 18, 1919. Wieland Herzfelde visited me this afternoon. He openly admits to being a Communist and supporter of the Spartacus League. . . . When I asked him who among the younger writers and artists sympathized wth the Spartacus and Bolshevist position, he named Däubler, Grosz, himself, and many others, everyone and anyone who is connected with the Malik-Verlag. . . .

Berlin, February 5, 1919. Called on the painter George Grosz this morning. . . . He said he would like to become the "German Hogarth," to be deliberately concrete and moralistic in his work. He wants to preach to the world, improve it, reform it. . . . When you come right down to it, Grosz is an artistic Bolshevist. He is disgusted by painting as we know it, by its pointlessness. He wants to achieve something completely new through the medium of painting or, to put it more correctly, something that earlier religious painters and painters like Hogarth used to do but that disappeared from painting in the course of the nineteenth century. . . . But intellectually speaking, much of his thinking is primitive and wide open to criticism.

Berlin, March 10, 1919. . . . The government announced this evening that the firing squads have begun to carry out summary executions. Thirty men have been mowed down for a start.

Berlin, March 13, 1919. . . . Däubler told me that soldiers tried to arrest the painter Grosz in his studio. But with the help of some false identity papers he had, Grosz was able to convince them he was someone else. Now he has gone underground. . . . The white terror rages on unabated. Government troops shot twenty-four sailors in the courtyard of a building on Französische Strasse in what can only be called an instance of blatant murder. All the sailors were there for was to pick up their pay from their paymaster. . . . Young says he is convinced that the spirit informing Noske and his troops is no other than that of the old militarism raising its head again. . . . No decent man can tolerate a government that is so casual and reckless with the lives of its citizens. The last week, burdened with guilt, cynical lies and bloodshed, has left a division in the German people that it will take decades to bridge.

Berlin, March 15, 1919. The executions continue. . . .

Berlin, March 16, 1919. . . . Grosz says that a number of artists and intellectuals ([Carl] Einstein, for one) have gone underground, hiding

39 *After Work,* 1919–20

out in one house one day and in another the next. He claims that the government is out to strip the Communists of their entire intellectual leadership. He feels he is safe again, and he is even preparing a second issue of *Die Pleite* [Bankruptcy], this time with cartoons more biting than those he has done before. Then he told me about several events of the last few days that obviously shook him to the core. He said he had seen Spartacists in battle, some ex-convicts among them. Their courage and fanatical devotion to the cause were inspiring beyond belief. This experience gave him a whole new sense of the proletariat. He felt it was the artist's or intellectual's duty simply to take his assigned place in the ranks. More disturbing yet: Near the Eden Hotel, he saw a lieutenant shoot down a soldier who had no identity papers and who answered the officer's questions in a rude tone. . . . Grosz counts himself a member of the Spartacus League now. He feels violence is necessary if the revolutionary idea is to be realized. There is no other way to overcome the inertia of the bourgeoisie. I disagreed, arguing that any idea becomes debased if it is paired with violence.[44]

The Politicization of Artists

The counterrevolutionary measures taken by the government did even more than the revolution itself to rouse a number of artists and intellectuals to action. This phase of politicization is of great importance for the development that all cultural life in Germany underwent in the early 1920s, and it was particularly influential in Grosz's case. The generation that was between twenty and thirty years old at the time was most deeply affected: Otto Dix and Conrad Felixmüller, George Grosz and Otto Griebel, Heinrich Hoerle, Karl Hubbuch, Otto Nagel and Otto Pankok, Karl Rössing and Rudolf Schlichter, Georg Scholz and Franz W. Seiwert. They saw the possibility of a major change taking place. For these artists and intellectuals, the change would involve much more than a proletarian revolution. It would mean the realization of utopia itself, a utopia that had never been more than a dream under Wilhelm II. Looking back on this period from the perspective of 1928, Grosz wrote: "It seemed to all of us that doors were opening and that the light was streaming in." The counterrevolution dashed all these hopes. "The doors were soon shut again and barred with double locks. This forced many of us to take a clear political stand."[45]

40 *Like Master, like Man—Even revolution brings profit*, 1920

The measures taken by the SPD forced artists and intellectuals into the radical opposition and led them to assume clearly partisan positions. After aligning themselves with the Spartacus League, George Grosz,[46] John Heartfield, Wieland Herzfelde, Johannes R. Becher, Erwin Piscator, Otto Nagel and Alfred Frank joined the KPD immediately after its founding in 1918–19. Throughout the 1920s, Grosz campaigned actively for Communist candidates in elections; and from 1919 on, his drawings appeared mainly in Communist newspapers and magazines and under the imprint of Communist publishers.

At this time, other writers and artists sided with radical Communist groups. Among them were Franz Jung and Oskar Kanehl, some of whose works Grosz illustrated; Carl Einstein, with whom Grosz edited a periodical; Max Herrmann-Neisse, of whom Grosz did a portrait in 1925 (Color Plate 6); Franz W. Seiwert and Heinrich Vogeler. These men were active primarily in the Workers' Union *(Allgemeine Arbeiter-Union*—AAU) and the Communist Workers' Party of Germany *(Kommunistische Arbeiter-Partei Deutschlands*—KAPD), which split off from the KPD in 1920. The writers Gustav Landauer, Erich Mühsam and Ernst Toller were active supporters of the Bavarian revolutionary government.

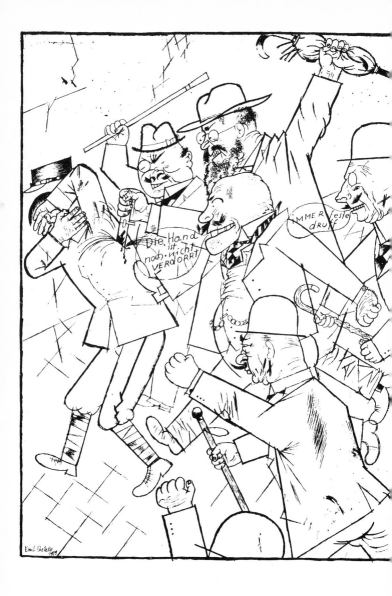

41 *When the bourgeois is enraged—*

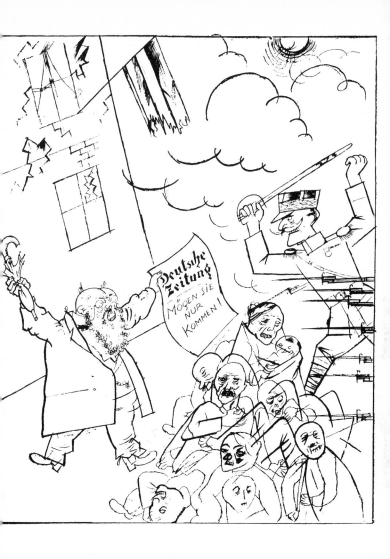

42 —*the proletarian has to pay,* 1919

But the revolution did more than just prompt individuals to join leftist parties and thus find what would be at least a temporary political home. It also showed them that changes in their fields of work could come about only as a result of a common effort. For a while, at any rate, shared cultural and political goals helped them overcome the isolation of which Grosz and others had complained. More or less permanent interest groups were formed, and unlike *Die Brücke* or *Der blaue Reiter,* they were not based on aesthetic principles. Instead, they focused on political goals to which the artistic preferences and leanings of their members were irrelevant. *Der blaue Reiter* (The Blue Rider), located in Munich, was another group of Expressionist artists [translators' note].

The Workers' Soviet and the November Group

Using the revolutionary workers' and soldiers' soviets as their model but without adhering to the election rules of those soviets, Bruno Taut, Walter Gropius, Adolf Behne and César Klein organized a Workers' Soviet for Art. This group was motivated by the "conviction that the present political revolution must be exploited to liberate art from the paternalistic control under which it has suffered for decades" (Program for the Workers' Soviet, 1918).[47]

The principles of the soviet were: "Art and the people must be made one. Art can no longer be enjoyed by the few but must become a joy and source of vitality for the masses." Since architects figured so prominently in the soviet, it was not surprising that the goal of the group was "to bring artists together under the aegis of a great architecture."[48] The first chairman was Bruno Taut. His successor was Walter Gropius, who declared himself delighted with the "sympathetic radical atmosphere" prevalent in the Workers' Soviet.[49] In the spring of 1919, the Workers' Soviet sent out a questionnaire to its members to gather information on which to base a unified position for the group.[50] Among the issues in need of clarification were basic reform in art education, changes in the public support of art under a socialist state, the formation of an artists' association, bridging the gap between art and the masses (one suggestion was to set up "state-sponsored exhibit locales to replace salon exhibits"), the use of color in city planning and the

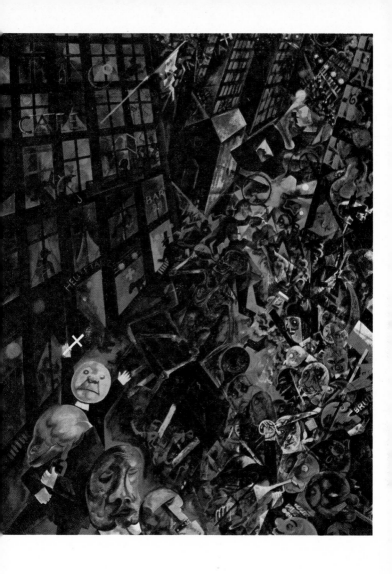

To Oskar Panizza, 1917–18

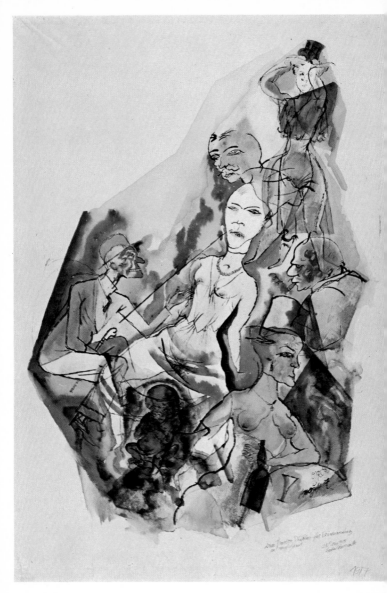

2 *Childbirth*, 1917

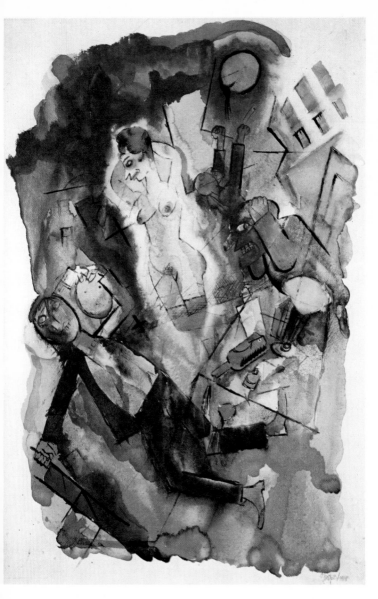

3 *Suicide,* 1918

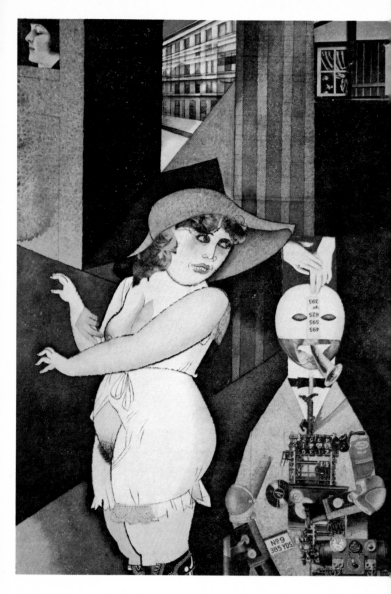

4 *Daum marries her pedantic automaton George*, 1920

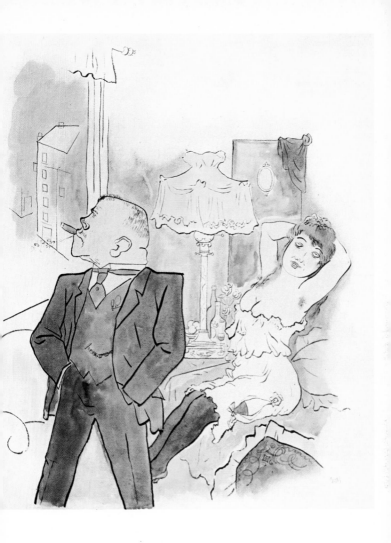

85 *Strength and Grace,* 1922

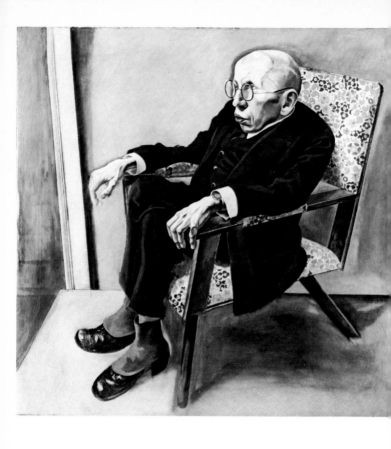

6 *Portrait of Max Herrmann-Neisse,* 1925

7 *Pillars of Society,* 1926 ▷

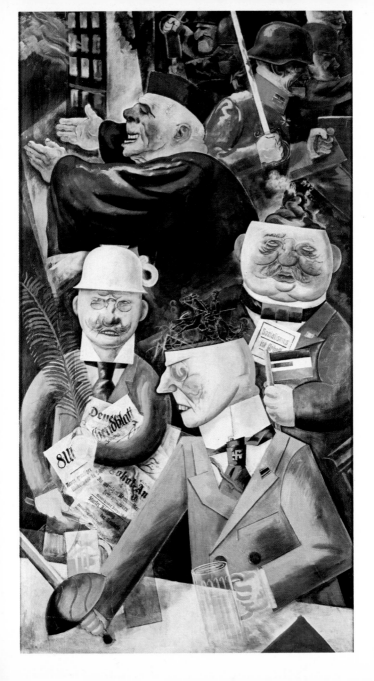

8 *Modern Short Story*, 1932

commissioning of artists to design public buildings. The final result was a list of suggestions, some of them thoroughly realistic, others purely utopian. It goes without saying that problems still of vital interest to us today were touched on then. The emphasis, however, was more on expanding artistic activity than on changing its nature; and in this sense, the Workers' Soviet did not do justice to the name it had borrowed from the revolutionary movement. But despite this, the group did focus on issues such as the role of art in public life and in the shaping of the environment, issues that had never been discussed with this kind of thoroughness before.

In May 1921, the Workers' Soviet for Art disbanded. Pechstein, Feininger, and Nolde had also been members.

Toward the end of 1918, Max Pechstein, César Klein, George Tappert, Heinrich Richter and Moritz Melzer founded still another group in Berlin. This was the *Novembergruppe* (November Group). Its goals were not as political as its name would suggest. But it did differ from previously existing artists' organizations by focusing on the relationship between art and politics and by acting as a united front. Other members of the November Group were Rudolf Belling, Walter Dexel, Otto Freundlich, Karl Völker and the architect Erich Mendelsohn. The Berlin Dadaists—among them George Grosz—and the Bauhaus artists exhibited under the sponsorship of the group.

A leaflet of January 1919, urging artists to join the group, begins with these words: "Painters, sculptors, architects of the new spirit! The revolution demands unity of us!" Next came the principles of the November Group:

 I. The "November Group" is the (German) association of radical artists.
 II. The "November Group" is not an organization to promote our economic interests, nor is its purpose (solely) to stage exhibits.
 III. By bringing together like-minded creative artists, the "November Group" wants to gain a decisive influence over decisions made on all questions relating to art.
 IV. We demand a voice
 1. in all architectural projects affecting the public . . .
 2. in the reorganization of art schools and of art instruction.
 3. in the reorganization of the museums . . .
 4. in the assigning of exhibition space . . .
 5. in all legislation affecting art . . .[51]

43 *For German Law and Morality*, 1920

44 *The Perfection of Democracy*, 1920 ▷

The November Group soon had a number of chapters in other German cities: the *Gruppe 1919* (Group 1919) in Dresden with Dix, Felixmüller and Griebel as members; the *Hallische Künstler-Gruppe* (Halle Artists' Group) in Halle; the *Vereinigung für neue Kunst und Literatur* (Association for New Art and Literature) in Magdeburg; *Der Wurf* (The Sketch) in Bielefeld; and *Rih* in Karlsruhe with Rudolf Schlichter and Georg Scholz.

Despite its protestations to the contrary, the November Group soon was doing little more than "staging exhibits."[52] It never advanced beyond bourgeois activity. In 1920–21, the founding of an Opposition to the November Group was announced in a letter that appeared in *Der Gegner* [The opponent], a periodical sympathetic to the KPD. This Opposition, which included Dix, Grosz, Hausmann, Schlichter, Scholz and others, claimed that the November Group had sacrificed its true purpose to the interest of its ambitious members. "It blocked all efforts toward achieving truly revolutionary and humane goals and even went so far as to admit that it was appalled to see the goals of the November Group being confused with, let alone equated with, the revolutionary and humanitarian goals of our time. Confusion of this kind had been detrimental to the economic success and the reputations of its prominent members."

The Opposition then defined its own position. "We know that it is our task to give expression to revolutionary impulses, to serve the masses, and to help effect the changes necessary in our time. We refuse to have anything to do with the aesthetic racketeers and academics of tomorrow. We do not pay mere lip service to the revolution, to the new society. Our commitment is genuine. We take the task we have set ourselves seriously, and that task is to help build a new human community, a community of working men and women."[53]

As a signatory to this open letter, Grosz must have been in basic agreement with it; and no matter how idealistically foggy the letter may be, it indicated that Grosz had now taken up a position completely different from the one he had held before the revolution.

45 It smells of common people here, 1921 ▷

"The movement I was caught up in influenced me so strongly that I considered any art worthless that could not be put to use in the political struggle. My art, at any rate, would be a rifle and a sword."[54] When Grosz came to write his autobiography years later, this is how he described his reaction to the revolution and the counterrevolution.

Dada in Berlin could not help but feel the influence of these events. In the early phase of Dada, Hausmann and Huelsenbeck had set the tone with their generalized opposition to the bourgeoisie and its overfed culture. Now Grosz, Heartfield, and Herzfelde took the reins in their hands. Anti-bourgeois sentiment was replaced by a clear political stance; provocative nonsense, by calculated political action.

"We spent a great deal of time discussing art," Erwin Piscator recalled, "and much of that discussion concerned the role of art in politics. We came to the conclusion that our art had to be turned to the service of the class struggle if it was to have any value at all."[55]

During this period, Grosz produced politically motivated work that instantly was put into circulation in the magazines and other publications of the Malik-Verlag. In February 1919, Wieland Herzfelde, collaborating with his brother and George Grosz, put out a magazine called *Jedermann sein eigner Fussball* [Every man his own soccer ball]. The first issue immediately was confiscated by the authorities, and no further numbers appeared. This one issue combined political commentary with bitter satire on the SPD government and a call for revolution. *Jedermann sein eigner Fussball* clearly favored a soviet republic for Germany. An ad for the *Kleine Grosz-Mappe* [Small Grosz portfolio] contained the line: "Berlin seen through the eyes of a Bolshevist."

Then, from February 1919 to January 1920, Wieland Herzfelde, John Heartfield and George Grosz published *Die Pleite* [Bankruptcy], a magazine specializing in political satire. The typography was Dadaistic, the principle behind it being to make the form mirror the content; and in this case the content was a mixture of various texts, notices, satires and advertisements. Several

46 *A Happy New Year!*, 1920

drawings by Grosz appeared in each issue. Grosz's primary targets in these drawings were the protagonists of the counterrevolution, i.e., Ebert and Noske, as well as big capital and the military. The authorities forbade further publication of *Die Pleite* on various occasions, too.

Another periodical that Wieland Herzfelde issued through his Malik-Verlag was *Der Gegner* [The opponent] (1919–22). Among the contributing artists were Grosz, Rudolf Schlichter, Otto Schmalhausen, Georg Scholz and Frans Masereel. *Der Gegner* was a political magazine, too, but its format and layout were nowhere near as frivolous as those of a magazine like *Die Pleite*. The drawings Grosz contributed to it had a simple and clearly agitprop character. But *Der Gegner* closely resembled *Die Pleite* in its Bolshevistic position. It opposed parliamentarianism and favored a new International.

The magazine *Der blutige Ernst* [Dead serious] appeared in the years 1919–20 and, starting with its third issue, was edited by Carl Einstein and George Grosz. Einstein, Hausmann, Huelsenbeck and Mehring supplied texts that combined Dada and political comment and that were accompanied by numerous large-format drawings by Grosz, again focusing on current political issues.

Satire was the essence of all these periodicals, and the informing principle for Grosz's drawings in this period. In an article entitled "On the Theory of Dadaism," which appeared in the *Dada Almanach,* the Dada advocate Daimonides (a pseudonym for the physician Dr. Döhmann) wrote: "The most appropriate technique that it [Dadaism] can utilize (but certainly not the only one available to it) is the parodistic, cynical or satirical representation of reality."[56] Satire makes use of exaggeration, irony and ridicule to illuminate reality. From an idealistic point of view, it shows how reality fails to live up to the ideal. From a materialistic point of view, it seeks to show that reality can be changed for the good. Political satire and Dadaistic irony are closely intertwined in all these publications that Grosz had a major part in shaping and that first printed many of his drawings.

Still another publication that the Malik-Verlag put out was the third issue of the magazine *Der Dada*. The issue appeared in April 1920 and was edited by "Grossfield, Hearthaus, Georgemann." This issue of *Der Dada* indulged in many more nonsensical

47 *No one else turns them out like this,* 1920

Dadaistic effects than had any of the other publications in which Herzfelde had been involved. Among other things, the issue carried a statement protesting the banning of a Chaplin film in Germany. The signatories included the Berlin Dadaists, with Grosz among them, as well as Arp, de Chirico, Max Ernst, Picabia, Schwitters and Tzara.

Grosz's Theory of Art around 1920: Class Struggle

Between 1920 and 1925—not before this and not again after—Grosz wrote about his views on the function of art, sometimes at considerable length. Our focus here will be on texts from the years 1920 to 1922.

In his essay "Stett einer Biographie" [In place of a biography],[57] written in 1920 for the magazine *Der Gegner,* Grosz launched an attack on bourgeois art. He said the painter in bourgeois society was, perhaps unwittingly, a mere "machine producing securities, a machine that the rich exploiter and aesthetic fop" took advantage of to invest his [exploiter's] money for profit and to improve his public image by playing the patron of the arts. He blamed artists for "behaving like charlatans and encouraging" the prevalent personality cult, the essence of which was: "The madder the genius, the greater the profit." The bourgeois artist, who demanded preferential treatment because he could not cope with life, was therefore at the mercy of "influential bigwigs," of the "whole reactionary fraud of art criticism," and of the art dealers, all of whom operated with "intellectual concepts" designed to do nothing but promote the "art boom." "We're all familiar with the cult of stars. That's how the system wants it, and business is thriving."

Grosz accused abstract painters of being "pathetic fellow travelers of the bourgeoisie." "Your brushes and pens, which should be used as weapons, are nothing but dried up wisps of straw." "Do you think you're working for the proletariat, which will be the bearer of the new culture?" "Leave your four walls, even if it's difficult for you. Put an end to your individual isolation. Let yourselves be inspired by the ideas of the working people. Help them in their battle against a corrupt society."

It was the duty of the revolutionary artist, Grosz went on, "to produce propaganda on two fronts. He must rid the world of supernatural forces, of God and the angels, and sharpen men's eyes so that they can see the realities of their relationship to the world around them."

"You must understand that it is the masses who are working to reshape the world order, not you! But you can help to create this new order. You can help if you only will! You can do this by

informing your works with a substance that derives from the revolutionary ideals of working people."

Grosz claimed that "only after the victory of the working class" would the "capitalist monopoly on the things of the spirit come to an end." This idea of the artist taking up the struggle on the side of the proletariat, which was seen as the source of the culture of the future, attested to the fundamental change that Grosz had undergone under the impact of the revolution. His statements were inspired by genuine anger, not just by political strategy. Revolutionary ideology may have come easily to his tongue now, but he had not yet systematized it for himself and made it fully his own. He had simply adopted its slogans, which remained simplistic when compared to his much more complex artistic practice.

This was the conclusion that Grosz drew for his own work: "Our society is dominated by a faith in private initiative, which is supposedly the sole source of happiness. The whole point of my work is to help destroy this faith and show the oppressed the true faces of their masters." And the basic assumption of his work was: "Contemporary art is dependent on the bourgeoisie and will die with it."

The *Kunstlump* Debate: Vandalism?

Despite Grosz's adoption of the Spartacus cause, his political position was still not altogether clear. He showed strong leanings toward anarchistic thinking, as the *Kunstlump* (or "art vandal") debate of 1920 showed. This is what had happened: The Kapp *putsch* sparked riots in Dresden as well as in other German cities, and while the people of Dresden were fighting to defend democracy a stray bullet struck a Rubens painting in the Zwinger museum. Oskar Kokoschka, who was a professor at the Dresden Academy at the time, issued a public statement in which he suggested, in all seriousness, that the fighting be moved out onto the heath outside of town or even be replaced by single combat between political leaders of opposing camps. "The German people will clearly derive more pleasure and happiness from looking at the paintings saved in this way than they will ever have from all the ideas of present-day German politicians taken together," ideas that Kokoschka regarded as "muddled" anyhow. (Pamphlet, Dresden, 1920).

48 *Where the Dividends Come From—*

49 *—Where They End Up*, 1921

Kokoschka's statement evoked a response from Grosz, who was claiming repeatedly at this point that there were more important problems to worry about than those of art; those problems were, in his view, "the problems of what our future will be, the problems of the new man, the problems of the class struggle."[58] Together with John Heartfield, Grosz wrote an article called *"Kunstlump."*[59]

Kokoschka's statement was, this article claimed, "a typical expression of the mentality prevalent in the entire bourgeoisie," a class that placed a higher value on its art and culture than it did on "the life of the working class." Grosz and Heartfield concluded "that there can be no reconciliation between the bourgeoisie, with its view of life and its culture, and the proletariat." "Workers! Every time an artist paints something that the bourgeois can cling to and that dazzles you with illusions of beauty and happiness, that artist is strengthening the bourgeoisie and sabotaging your class consciousness, your will to power."

Grosz and Heartfield were "delighted that the bullets flew into galleries and palaces, into Rubens masterpieces, and not into the houses of the poor." All possible means and every last ounce of intelligence and persistence must be directed at bringing about the fall of this "exploitative culture" as quickly as possible.

This article, riddled with verbal abuse and utterly one-sided in its argument, had the provocative character of Dada. But because it had raised a serious political question, i.e., what function and value would the cultural legacy have under socialism, it prompted a weighty discussion that was drawn out for several weeks in the pages of *Die Rote Fahne* [The red flag], *Die Aktion* [Action], and *Der Gegner* [The opponent].

Die Rote Fahne condemned Kokoschka's statement, too, but refused to follow Grosz and Heartfield in encouraging vandalism and chaos. It simply was not true, the magazine said, "that the dusty works of a Rembrandt or a Rubens are of no value to the worker anymore." Not the destruction of such works but a historical and critical analysis of them would lead to enlightenment and would give "the revolutionary clarity about his goals." All art informs us about the nature and character of the past. "The proletarian cannot destroy the very ground on which he stands and on which he must build the future."[60]

Grosz's and Heartfield's reaction to Kokoschka's statement was not purely political but psychological as well. At this point,

50 *In the Bar*, 1921

51 *At the Regulars' Table*, 1919 ▷

10

Kokoschka was the very personification of the Expressionism that the Dadaists were condemning so roundly. They were reacting as Dadaists by arguing against tradition (just as the Italian Futurists had called for the destruction of museums) and by deliberately trying to shock the bourgeoisie.

Support for Grosz's and Heartfield's views came from the left-wing Communist painter Franz W. Seiwert, who wrote in *Die Aktion:* "Away with all this respect for bourgeois culture! Down with all the old idols! In the name of the proletarian culture of the future!"[61]

August Thalheimer, the editor-in-chief of *Die Rote Fahne,* took a contrary view. He thought the "ultra-revolutionary" rejection of the art of the past, by Grosz, Heartfield and Seiwert, was in reality a "bourgeois battlecry," "a mirror image of the methods of the fading, self-destructive bourgeoisie." It could produce only a "considerable weakening of the proletariat's political struggle."[62]

The conclusion that came out of this debate was that Grosz's and Heartfield's provocative statements could not stand up under close examination. The methods of political Dada were inadequate for solving the complex problem of the value and uses of the cultural heritage. But at the same time, it was felt that *Die Rote Fahne*'s assertion of the eternal value of art reflected those same bourgeois views of culture that Grosz and Heartfield had attacked.

For their part, Grosz and Heartfield received a reprimand from the KPD, to which they belonged and on whose behalf they meant to speak. The party condemned their anarchistic position. In 1921, in an essay entitled "Gesellschaft, Künstler und Kommunismus" [Society, artists and communism], Wieland Herzfelde attempted to clarify the whole issue and at the same time justify Grosz's and Heartfield's action. Generally speaking, Dada and political art have a common root in the "anarchistic tendencies of the artist," but these tendencies must be overcome if the artist is effectively to serve the revolutionary struggle of the working class.[63]

This entire incident accurately reflected Grosz's situation around 1920. Encouraged by the revolution, Grosz attacked the petit bourgeois world from which he himself had sprung. The result was a certain confusion about his own political position, and this confusion was much more evident in his verbal statements than in his artistic works.

The Dada Fair and the Grosz Trial

The first wave of Dada activity in Berlin was followed by events that prompted more discussion and agitation. Once again the relationship between Dada and politics was the major issue. In July and August 1920, an exhibit entitled the "Erste Internationale Dada-Messe" [First international dada fair] and organized by Grosz, Hausmann, and Heartfield, was held in the Berlin gallery of Dr. Otto Burchard at Lützowufer 13.

The exhibit included works by Grosz (Color Plate 4), Heartfield, Hausmann, Höch, Max Ernst, Otto Dix, Hans Arp, Rudolf Schlichter, Otto Schmalhausen, Alfred Baader, Francis Picabia and others. The catalog listed 174 works in all. Along with Dada works that shocked art lovers and that were described by the Berlin newspapers as "gags" and "amusing nonsense," the exhibit contained a number of banners that said such things as "Dada fights on the side of the revolutionary proletariat." The prospectus for the exhibit announced: "The Dada movement will put an end to trading in art" and "the Dadaist is a radical opponent of exploitation."

One of the items in the exhibit was a large doll, probably made by Rudolf Schlichter. "From the ceiling of the exhibit hall hung the stuffed figure of a soldier, wearing a field gray uniform and officer's epaulets. The figure had a pig's face under its field cap. . . . The comment the exhibitors had supplied for this figure read: If you want to understand this work, you should drill for twelve hours every day on the Tempelhof parade grounds carrying a full field pack."[64]

In his foreword to the exhibit catalog, Herzfelde defined Dadaistic works as ones that "destroy illusions . . . without regard for public values or government authority." They spring from a need "to advance the present-day world by undermining the status quo."

Even though this exhibit reflected the Dada mentality in its full complexity, it would not demand our attention here except that its consequences showed it was intended—and used, at least by Grosz and the Herzfeldes—as a Dadaistic weapon in the struggle against capitalism, militarism and the church. One of the items exhibited by Grosz was his portfolio *Gott mit uns* [God on our side]—1920.

The reaction of an anonymous visitor to the exhibit was "that we have some people in Germany we could do without." Another visitor filed a complaint, accusing "Dada Chief" Johannes Baader, Dr. Otto Burchard, George Grosz, Wieland Herzfelde and Rudolf Schlichter of having "insulted the German army." The offending works were the stuffed figure of an officer and Grosz's *Gott mit uns* [God on our side]. Grosz's drawings were confiscated from Herzfelde's Malik-Verlag without a warrant. "If the army feels itself to be insulted," Kurt Tucholsky wrote about the trial, "we can only feel sorry for it. If Grosz's critique does not apply, then there is no reason for putting a district attorney to work on the case, a district attorney, by the by, who was an officer during the war and is therefore biased. But if Grosz's critique does apply, then he had every good reason to express it." According to Tucholsky, Grosz had "mercilessly exposed German militarism as practiced from the time of Wilhelm II to that of his most odious successor, that traitor to the working class, Noske." Grosz had been harsh and unsparing, but "it's not the mirror's fault if it shows a virgin she is pregnant."[65]

During the trial, Grosz and Herzfelde played down the politically explosive force of the exhibit. Their intention, they claimed, had been to present, "in purely artistic form, a satire on military excesses." But they were in fact attacking principles, not excesses. The expert witness Paul Ferdinand Schmidt, director of the municipal art collections in Dresden, played down the political aspect even more. He called the exhibit humorous and satirical in nature and called Grosz one of the most talented and important graphic artists of his day. Tucholsky's comment was: "The trial watered blood down until it was lemonade. Even if Grosz didn't mean what he said, we did."[66]

The prosecutor said the offending works constituted "a gross insult to the German army, executed in the most scurrilous form." Grosz was fined 300 marks, Herzfelde 600. The printing plates had to be destroyed, and control of the copyright was transferred to the ministry of the army. The "amusing nonsense" was serious enough that the authorities saw their army endangered and felt compelled to interfere.

The Dada Fair produced still another reaction that should be mentioned here. The Communist periodical *Die Rote Fahne* published a notice on the fair in 1920. The magazine said, "Pretending that this collection of perverse works represents a

52 *Death's Procurers,* 1919

cultural or artistic achievement is not a joke but an impertinence."
The artists were advised not to call themselves Communists. *Die
Rote Fahne* could find not the slightest resemblance between the
absurdity of Dada and the seriousness of the proletarian struggle
for liberation, and it raised as an objection to Dada that a
"working-class revolutionary . . . does not find it necessary, as the
Dadaists do, to destroy works of art in order to free himself from
'bourgeois attitudes' because there is nothing bourgeois about him
to begin with." But the Dadaists are bourgeois, and they have to
make a conscious effort "to rid themselves of 'bourgeois
attitudes.' " "Anyone who can do nothing better than glue together
works of idiotic *kitsch*," *Die Rote Fahne* said, "should stay away
from art altogether." By making this claim, however, the magazine
was asserting that art was something sublime and thus propounding
the very view that Dada was attacking.[67] It was obvious that Grosz's
views would continue to clash with such expectations for art.

Even Tucholsky was not absolutely convinced in his review that
the Dada exhibit was really of great artistic significance. But he felt
there was one real artist among the exhibitors. "He knocks you for
a loop. It's worth going to the exhibit to see this one artist. His name
is George Grosz. He is first-rate, a satirist of incredible ferocity. If
drawings could kill, the Prussian military would surely be dead."[68]

Paintings and Collages (1918–20)

During the war, Grosz did some paintings, mostly on urban
themes, in which he applied the same principles he used in his
drawings of 1917–18. One of the most successful of these paintings
was *To Oskar Panizza* (1917–18), a painting that presented the
phenomena of big city life, the crass simultaneity of pleasure and
death, in the form of a furious maelstrom. What we see here is the
world as chaos, rushing irrevocably toward catastrophe (Color
Plate 1).

A year later Grosz completed what was probably his most
powerful painting: *Germany, A Winter's Tale* (Illus. 53). In his
autobiography, Grosz wrote that this "political picture" captured
the entire range of his feelings after the revolution. "In the middle
of the painting I placed the eternal German bourgeois, fat and

fearful, sitting at a wobbly little table with a cigar and morning newspaper on it. At the bottom of the picture I put those three pillars of society: the army, the church and the school (a schoolteacher wielding his black, white and red rod). The bourgeois is hanging onto his knife and fork. The world is tottering around him. A sailor symbolizing the revolution and a prostitute rounded out my image of those times."

Like Dix's *War Cripple* and *Trenches* (both 1920), Grosz's *Winter's Tale* was one of the incunabula of social protest art. All three of these pictures have been destroyed or lost.

Grosz's *Winter's Tale* soon was regarded as a "classical document of the recent past"[69] because it held up a mirror to the times and was instantly understood. In the first monograph ever published on Grosz, Willi Wolfradt's study of 1921, we get an idea of the impact the picture made at the time and what possibilities for identification it offered the observer. Wolfradt wrote that Grosz did not shy away

> from combining sexual, middle-class, and military horrors in grandly frivolous compositions, especially in oils and in watercolors. The large format painting *Germany, A Winter's Tale* is a good example. In a futuristic meld, it combines elements from a bordello, factory, parlor, church, and barracks, inhabited by a stolid reserve officer with his beer, his food, and his local paper. And below him stand those three patron saints of the age. . . . Everything is in bright colors, as in a chromolithograph, the paint laid on thickly. In the bottom left-hand corner, Grosz himself appears like the portrait of a patron worked into a Renaissance painting. Here, however, he takes the form of a dark silhouette with a bitter expression, a figure glowering at death and close to suicide himself (if I am not misinterpreting the red hole on his temple). It is impossible to forget those three hypocritical, hyper-bourgeois criminal countenances. They remain as a suffocating presence in the memory: that saber-wielding philistine fuming with animal rage, that schoolroom philistine with a face like a bartender, that philistine of redemption, passing out hypocritical blessings. And above them, under the very eyes of these guardians of the social order, as it were, we see an orgy of triviality and licentiousness, a turmoil of disintegrating colors and forms.[70]

Collages were of great importance in Berlin Dada, as the work of Raoul Hausmann and Hanna Höch showed. For the Dadaist, the collage had two major functions. It allowed him to polemicize

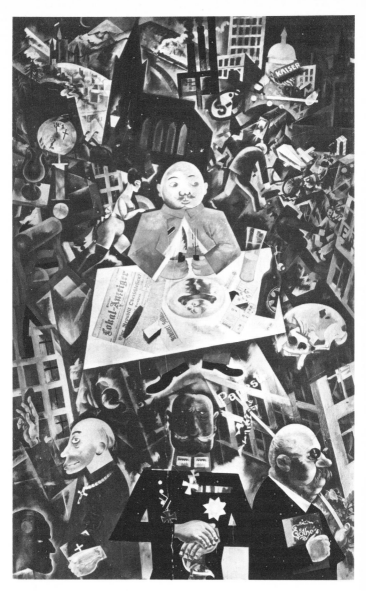

53 *Germany, A Winter's Tale,* 1917–19

against the painted images of the Expressionists and, by combining particles of reality, to mirror the chaos of modern civilization as the Dadaists perceived it.

Grosz, too, did several collages in this period, although he was not primarily interested in the collage as a pictorial medium. But around 1920 he did occasionally paste material from printed sources into pictures executed with conventional techniques.

A year after *Germany, A Winter's Tale,* Grosz was composing geometrically arranged street scenes and interiors in which depersonalized figures appeared and met. The collage elements introduced a technological element into these paintings and watercolors. Grosz sometimes emphasized the almost complete obliteration of individual features in these pictures by stamping his name on them rather than signing them.

In 1921, Grosz published some works of this kind that he had done in 1920 in Paul Westheim's periodical *Das Kunstblatt* [The art paper]. Grosz printed an explanatory text with them.[71] The "artistic revolutions of painters and writers," Grosz wrote, are "of course, interesting and of aesthetic value"; but "in the final analysis, their interest remains limited to the atelier" because the artists "are not grasping revolutionary problems clearly enough." In his new pictures, Grosz wanted to transmit "an absolutely realistic picture of the world" that could be "understood by everyone." In attempting to do this, the artist "could not help adopting something of Carrà's manner," even though Carra's point of view was "bourgeois." The works of the Italian *pittura metafisica,* the works of Carlo Carrà and Giorgio de Chirico, reproductions of which had appeared in periodicals in Germany, influenced many artists at this time. Even Max Ernst came under the influence of the Italians in 1919.

Grosz called his Constructivist pictures "training work," "a systematic focusing on the work at hand—without any gazing off into eternity." He had not indulged in any "psychological probing" or tried to present his figures as individuals. He had instead thought of them "in collective, almost mechanical terms." "The fate of the individual is no longer important." Like Hoerle and Seiwert in Cologne, Grosz came to the conclusion that a technological world, a world of mass movements, called for a non-individualistic style of painting that utilized the principles of mechanical drawing and, in

doing so, depicted situations representative of the modern world. Gross emphasized that lines should be "un-individual" and color effects dampened. "We are no longer intent on conjuring up colorful Expressionist landscapes of the soul on our canvases. The objectivity and clarity of an engineer's blueprints are better models than unverifiable rantings about the cabala, metaphysics and the ecstasies of saints."

In one spurt of work in 1920 Grosz produced a number of Constructivist paintings and watercolors (Color Plate 4). He never returned to this mode again. In his writings of this period, he linked his revolutionary purpose with his Constructivist principles. As was very often the case, Grosz worked on several levels at once. He constantly was making new attempts to break out of artistic convention, to find new solutions that were appropriate to his times and that would put his relationship to reality on a more solid basis. It was precisely this kind of firm footing that he lacked, despite his protestations to the contrary. Where his political drawings of this period were polemic in character his Constructivist works were general, symbolic statements at the other end of the spectrum. They represented an effort to consolidate rather than to tear apart, to harmonize rather than to analyze.

Grosz's Alternatives to Traditional Art Forms

Soon after completing his *Winter's Tale* and his Constructivist works, Grosz made a fresh attack on the theoretical and practical question of what artistic means were suitable for conveying new political attitudes. What alternatives to traditional art forms would be optimally effective in reaching a wide audience? As Grosz saw it, "In our struggle against the stupidity and arbitrary brutality of the present government, it no longer makes sense for a productive artist to work in the old modes."[72]

Motion pictures were a medium he thought promising. "Film is the most modern pictorial medium we have. . . . It will produce the art of the future. If you really want to know what the world looks like, you go to a movie, not to an art exhibit. One half of art—and for most people the more important half—is more perfectly realized in the movies than it ever has been before."[73] "Because many people work together on a film, it is more likely to have a

54 *Republican Automatons*, 1920

social impact than the hand-crafted work of an individual artist."[74] Despite this enthusiasm for film, Grosz was involved in only one film project himself. In his 1928 production of *The Good Soldier Schweik,* Piscator projected on a backdrop a film based on drawings Grosz had made for this production. Other artists were discovering the film as a medium at about this same time, among them Surrealists such as Man Ray and Bauhaus artists such as László Moholy-Nagy.

But the field that most attracted Grosz was journalism. The "journalistic cartoonist with access to a printing press . . . will still be at work long after the easel painters have died out. He is politically motivated, just like his counterpart in America." This kind of artist, Grosz felt, would come to be classified "with the technical artists and painters working in industry and advertising, with constructivist draftsmen, and with inventors and engineers."[75]

Most of Grosz's work at this time was topical and political in nature and intended for publication in magazines and newspapers, even though much of it appeared in books and portfolios as well. We already have mentioned his numerous contributions to the Malik-Verlag publications *Jedermann sein eigner Fussball, Die Pleite* and *Der Gegner,* as well as to *Der blutige Ernst,* published by the Berlin Trianon-Verlag. The only other publications Grosz worked for until 1925 were Communist newspapers. One of these was the "satirical workers' paper" *Der Knüppel* [The cudgel], which appeared every two weeks from 1923 to 1927 and carried at least one drawing by Grosz in every issue during the time he was working for it. He also contributed occasionally to *Die Rote Fahne* [The red flag], the Communist Party organ, which appeared from 1921 to 1928. Grosz's drawings did not begin to appear in *Simplicissimus* until 1926, but from then on he was a regular contributor until 1932.

But in the last analysis, Grosz did not adhere strictly to his convictions. From the mid-1920s on, prestigious private galleries staged one-man shows of his work. At this same time, his cohort John Heartfield turned completely to journalism. His photomontages commenting on current events were circulated widely in illustrated papers aimed at the working class. They received no attention whatsoever in the art world.

Grosz's drawings published between 1919 and 1925 in leftist newspapers and magazines no doubt reached the audience he was

55 *Handsome Fritz,* 1920

most interested in supporting and educating. But at the same time his books and portfolios were designed for a public that was by no means proletarian. Grosz and his publisher Herzfelde took this into account by issuing different editions of the portfolios and books. As a rule, they published signed special editions on quality paper. These editions cost vastly more than the regular, usually unsigned editions and were priced to cover most of the production costs so that the regular editions could be sold very cheaply. For example, *Die Räuber* ([The robbers] nine lithographs—1922) appeared in four different editions: Five copies costing 300 marks each were bound in vellum and printed on hand-laid Japan paper. Thirty-five copies priced at 150 marks each were bound in silk and printed on a lower-grade paper. Fifty-five copies bound in cloth sold for 100 marks each. Finally, an unlimited edition—slightly smaller in format, unsigned and in a paper folder—sold for 3 marks per copy.[76]

Grosz's Portfolios from 1920 to 1923: Dialectical Pictures

Grosz published the major part of the drawings he did from 1918 to 1923 in a series of books and portfolios. These publications, all issued by the Malik-Verlag, received wide circulation and made Grosz a famous artist. They consisted mainly of drawings transferred to lithograph plates by photomechanical means. Most of these drawings already had appeared in magazines or newspapers in the same or slightly different form.

The years around 1920 were a golden age for graphic cycles. Max Beckmann's *Gesichter* [Faces] and Magnus Zeller's *Revolutionszeit* [Time of revolution] appeared in 1919, Hoerle's *Krüppel* [Cripples] in 1920, Käthe Kollwitz's *Kreig* [War] and Beckmann's *Berliner Reise* [Berlin journey] in 1922, and, in 1924, Dix's *Krieg* [War] and Karl Völker's *1924*.

In this same period Grosz published the portfolios *Gott mit uns* [God on our side] (9 lithographs—1921), *Im Schatten* [In the shadows] (9 lithographs—1921), and *Die Räuber* [The robbers] (9 lithographs—1922) as well as the books *Das Gesicht der herrschenden Klasse* [The face of the ruling class] (55 illustrations—1921), *Abrechnung folgt!* [Accounts to be settled] (57 illustrations—1923), and *Ecce Homo* (100 illustrations—1923).

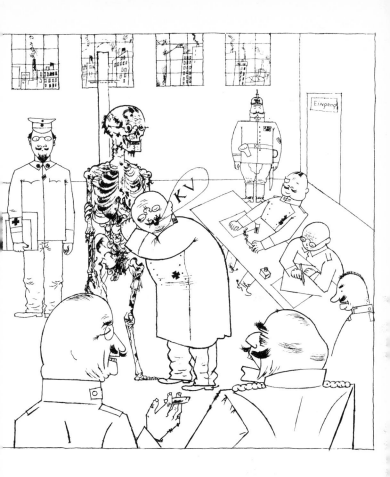

56 *The Faith Healers*, 1918

57 *The Communists fall—and the stocks rise*, 1920 ▷

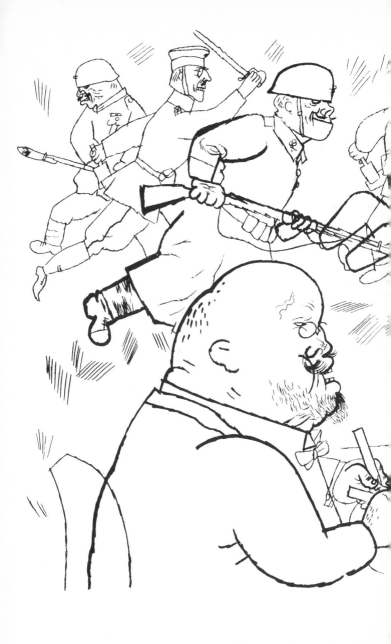

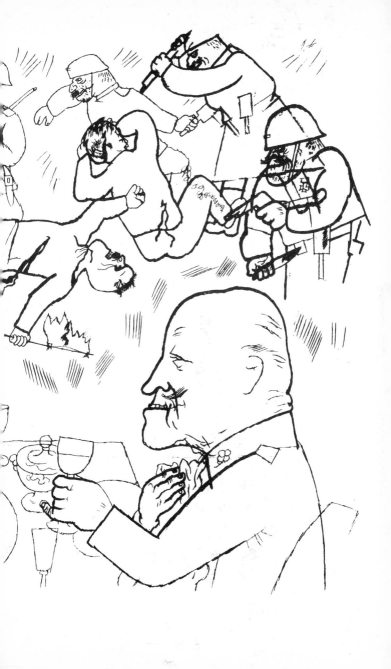

Gott mit uns [God on our side] contained mainly anti-military drawings in which Grosz pilloried the continuing power of Prussian militarism in the Weimar Republic. "Every middle-class family," Tucholsky wrote in 1921, "should have a copy of *Gott mit uns* on the coffee table. The unreality in Grosz's caricatures of majors and sergeants conjures up all the horrors of reality."[77]

The drawing *The Faith Healers* (Illus. 56), which first appeared in *Die Pleite* [Bankruptcy] and then later under different titles in other publications, also was included in this portfolio. An army doctor wearing a medal was shown declaring a skeleton fit for military duty. This drawing was said to have inspired Brecht's poem "Legende von Teten Soldaten" [The legend of the dead soldier].[78]

Two pictures made direct reference to the revolution. In *After Work* (Illus. 39), a soldier was shown calmly smoking a cigar after killing a revolutionary whose body was lying on the banks of the Isar. The city in the background clearly suggested Munich. This lithograph particularly offended the authorities and moved them to initiate the 1920 proceedings against Grosz. A theme that preoccupied Grosz was the combination of the idyllic and the violent: cigars and murders, liles of the valley and maimings, the petit bourgeois who commits murder on command. The other lithograph on the subject of the revolution was called *The Communists fall—and the stocks rise.* Workers were being killed in the background while profiteers calmly savored their food and drink (Illus. 57).

Grosz began developing a pictorial principle here that Heartfield would bring to perfection in his photomontages. In one picture, Grosz presented two different events from the worlds of two opposing social classes. The title supplied the connection between the two events, thus emphasizing the cause-and-effect relationship. Grosz's simultaneous portrayal of government-sponsored murder and private gain suggested that restoring law and order improves business and, conversely, that the state plays into the hands of entrepreneurs by working against the interests of the people.

Pictures such as this showed the relationship between seemingly contrary elements, reduced reality to key images, and thus laid claim to exposing causal relationships. They were dialectically conceived. They did not reveal individual artistic problems but used pictorial means to illuminate social conditions. In such works,

Grosz came closest to realizing the intentions expressed in his polemical political writings.

No one can expect either philosophical discussions or fundamental insights from a picture; neither one lies in the nature of pictorial art. But, as Grosz showed with these pictures, visual art can give concrete form to insights about society. This is precisely what Grosz achieved with his dialectical pictures. He distilled reality and made its structure so visible that his pictures had a provocative character. They forced the observer to take sides.

Grosz continued to work with simple outlines. What appeared inside them helped accentuate and caricature the essential traits of a personality. The line was robust in execution but sacrificed neither spontaneity nor virtuosity. Thicker lines created accents, emphasizing the brutal heads of soldiers or the marks of suffering in the oppressed. The formal means were placed directly in the service of the content. This was not the case in the drawings before 1919 in which the pen stroke had a pictorial value of its own.

The portfolio *Im Schatten* [In the shadows] (1921) focused almost entirely on the underprivileged, on workers and beggars, on war cripples and the unemployed. In the 1920s, Grosz came under attack—especially from the KPD—for being so caught up in his sallies against the government and the profiteers that he had failed to show the working class in a positive light. It is obvious that Grosz did not prepare the way for socialist realism. His skepticism prevented him from such excursions into the positive. But *Im Schatten* [In the shadows] at least suggested some sympathy for the sufferings and hardships of those who were forced to sell their labor.

Sympathy, however, has little use for satire; and the lithographs in this portfolio that lacked a satirical element also lacked force and tension. Grosz's great strength lay in oversimplification and exaggeration inspired by rage and indignation. It is clear that whenever Grosz's pen was not guided by anger, his drawings remained mediocre illustrations.

Another lithograph from *Im Schatten* [In the shadows] that made use of the dialectical principle was *At Five in the Morning!* (Illus. 60). It did not condemn the high living shown in the lower part of the picture, but the fact that this high living went on at the expense of the worker. Grosz used dialectical confrontations of this kind to

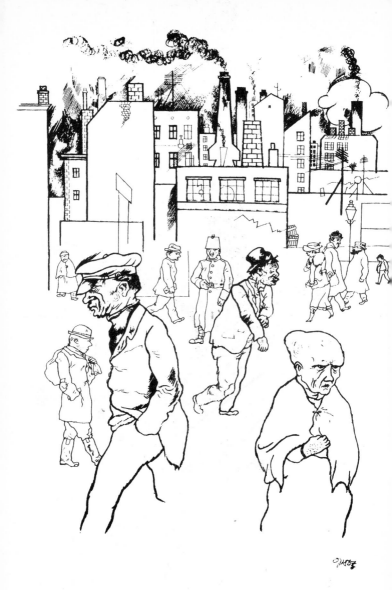

58 *In Front of the Factories,* 1921

59 *War Cripples and Workers*, 1921

compensate for the inability of static images to do analytical work, and what always interested him most in these confrontations were causes and effects, not just the lampooning of the upper classes.

The books *Das Gesicht der herrschenden Klasse* [The face of the ruling class] (1921), *Abrechnung folgt!* [Accounts to be settled] and *Ecce Homo* (both 1923) included several drawings that already had appeared in the portfolios, but they also contained a number of new works.

The major theme of these books was the counterrevolution. The drawing "The restoration of law and order"—for the sake of which Ebert, Scheidemann, and Noske put aside their differences—was shown to be a military campaign in which citizens were beaten, thrown into prison and shot without a trial.

Shot While Trying to Escape (Illus. 61) alluded to the official story that was propagated to cover up the murders of Rosa Luxemburg and Karl Liebknecht. An officer and a soldier armed with a sword, pistol and hand grenade were shown attacking a man tied to a stake. In *For the Sake of the Fatherland* workers were shot down by soldiers, one of whom has a swastika on his helmet. *Like Master, like Man — Even revolution brings profit* showed army and *Freikorps* troops robbing the body of a man they had just killed (Illus. 40).

First Lieutenant Marloh was the officer responsible for shooting down twenty-eight innocent men in March 1919 on Französische Strasse in Berlin. (This was the incident Count Kessler mentioned in his diary entry of March 10, 1919.) Grosz commented on this incident in *Marloh After — Anyone who wants to be a knight of the swastika* (Illus. 62) . . . *and Marloh Before — has to start practicing early* (Illus. 63). The second of these two drawings showed Marloh taking part in the massacre. In the first, he was reveling in wealth acquired through Nazi crimes. Grosz recognized the danger of fascism early in the 1920s, as did Heartfield, who published an anti-fascist drawing in *Die Pleite* in 1923.

Again and again, Grosz emphasized that the Prussian and Wilhelminian tradition had continued unbroken. Ebert was shown as a fat chief of state wearing a crown *(From the Life of a Socialist)*, the Weimar government as a successor to the royal family *(Hohenzollern Renaissance),* and the re-emergence of Ludendorff as a remilitarization of the country *(Ludendorff's Return).*

Grosz accompanied these harsh caricatures of the counterrevolution with an appeal to the people to rise up and join the class struggle. The last drawing in *Abrechnung folgt!* [Accounts to be settled] was called *Condemned of the Earth, Awake!* In another drawing, a politician and the commander of the *Freikorps*, both hanging on the gallows, wished each other *A Happy New Year* (Illus. 46). When Walter Rathenau, Minister for Foreign Affairs, was assassinated by right-wing radicals in 1922, Grosz designed a poster that was reprinted in *Abrechnung folgt!* [Accounts to be settled] and included the following texts:

> The German empire is what we long for in our future
> (from a speech given by Helfferich in the Reichstag on
> June 22).
> If we ever get our kaiser back
> We'll thrash Chancellor Wirth blue and black.
> You'll hear our guns go bang! bang! bang!
> As we shoot down
> The Nazis and the Communist gang.
> (From a song popular among reactionaries)

The concluding message on the poster was an appeal to the people:

> Workers! See to it that people like this are rendered harmless!

Another drawing was entitled *If the workers want to stop being slaves, they will have to take the club away from their masters.* These drawings and texts incited to rebellion and obviously were meant as instructions for translating the policies of the Communist Party into action.

Of course, attacks on capitalism recurred time and again in these books. *Where the dividends come from — and where they end up* (Illus. 48, 49) was another double drawing that juxtaposed the exploiters and the exploited. In *Dependency Decreed by God* (Illus. 64) Grosz showed how the military, the upper classes that belonged to dueling fraternities, the petit bourgeois and the proletariat all depended on capital. *Swim if you can; and if you can't, drown* caricatured the Darwinian principle of the survival of the fittest as it functioned in capitalism. *The spoils of war are for the rich, the misery of it for the people* showed how war cripples some and makes others rich. In *Be fruitful and multiply* Grosz condemned the church for blessing capital instead of siding with the poor.

60 *At Five in the Morning!*, 1921

61 *Shot While Trying to Escape,* 1921

In *Spartacus on Trial* Grosz attacked the legal system by depicting the judges as military men or capitalists who wield a whip labeled "Class Justice." One of the few drawings that pictured the way things should be was called *How the Court Should Look* and was first published in *Der blutige Ernst* [Dead serious] in 1919. In this drawing, workers sat as judges under a portrait of Karl Liebknecht, and military men were shown as the defendants (Illus. 36).

62 *Marloh After—Anyone who wants to be a knight of the swastika. . .*

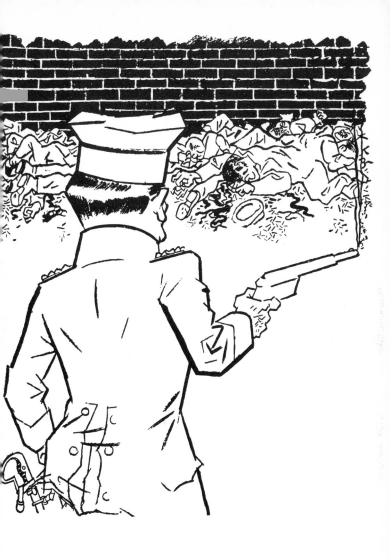

63 —and Marloh Before . . . has to start practicing early, 1923

Grosz's Political Position

Grosz's satirical pen revealed the true nature of different social groups and interest groups. To caricature a certain type, he drew on symbols that represented the entire group and that were recognized easily by the observer as characteristic of that group. Monocles, mustaches, beards, dueling scars, cigars, bared teeth or tie pins—these accessories and physical attributes stood for certain types, presenting them not as individuals but as incarnations of social groups.

Satirical exaggeration made the contrast between medals and war wounds, luxury and poverty, all the more vivid. The patriotic philistine's head was full of steaming manure. The entrepreneur wallowed in 10,000-mark bills. The *Freikorps* officer had a baby speared on his bayonet. The industrialist squatted on a pile of skulls.

This kind of exaggeration did not produce realism in the sense of a neutral reproduction of circumstances and surfaces but rather a realism based on analysis and employed as a partisan weapon. Grosz himself coined the term "tendentious art" for this kind of realism, and we will look more closely at this concept later. Mayakovsky, whose literary principles were very similar to Grosz's pictorial ones,[79] used the term "tendentious realism."

In this usage, "realism" represented an attitude, not a concept of style. As Bertolt Brecht put it, "A realistic point of view is one that studies the moving forces behind events. A realistic mode of action is one that sets those moving forces in motion." Realistic works "raise an objection (and become advocates for that objection) that martials new moving forces against established views and ways of doing things."[80]

Grosz's political position continued to be many-faceted. The proletarian and revolutionary stance of *How the Court Should Look* (Illus. 36) recurred only rarely. Along with works that took a clear stand in the class struggle, we find others that were no more than general anti-militaristic statements, still others that were limited to ridiculing the philistinism of the bourgeoisie. Dialectical pictures occurred, but they were not the rule. The spectrum ranged from a general anti-bourgeois attitude to a clear Communist position.

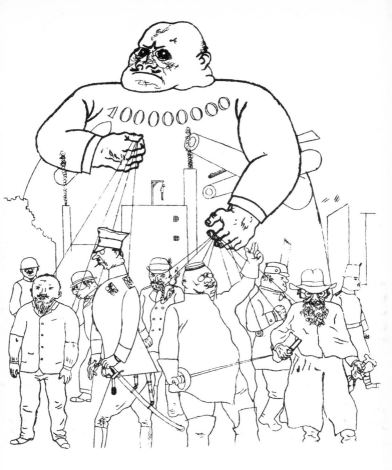

64 *Dependency Decreed by God,* 1921

What is beyond doubt is that Grosz's political position arose from a violent and often emotional reaction to the war and the counterrevolution. But he did not favor and fight for anything, such as socialism, to the same extent that he attacked what he despised. The result was some concurrence, but no full identification, with the Communists' intentions.

Despite this, the Communist Party of Germany was unreservedly enthusiastic about Grosz's portfolios. *Die Rote Fahne* said in 1921: "Germany has never had a satirical genius of this stature before." *Das Gesicht der herrschenden Klasse* [The face of the ruling class] was "an archive that gives a more accurate picture of history than thousands of documents can."[81]

Die Rote Fahne saw *Abrechnung folgt!* [Accounts to be settled] as supportive of the party's efforts in the class struggle: "This collection of accusations that his pen has turned out hammer at us and speak so clearly to us that we are sometimes shaken to the core. Everything alive in us ... rebels more spontaneously and passionately."[82]

In 1925, *Die Rote Fahne* wrote that Käthe Kollwitz and Heinrich Zille were "not conscious portrayers of the class struggle" and that this was their great weakness. "But their artistic work can still be turned to good use in the class struggle."[83] This same point may well have been behind the magazine's assessment of Grosz, too, which became, however, somewhat more negative in 1925. *Die Rote Fahne* said at that time: "The purely negative element" in Grosz's work prevented him "from balancing his biting criticism of the bourgeoisie with a portrayal of what is positive in today's society, i.e., the struggle and heroism of the proletariat. This is a flaw that characterizes not only George Grosz's work but all other manifestations of German revolutionary art."[84] This judgment was for the most part correct, at least until the founding of Asso (*Assoziation revolutionärer bildender Künstler Deutschlands*—Association of Revolutionary German Artists), which prepared the way for socialist realism. As a rule, bourgeois artists in the twentieth century—and Grosz was a bourgeois artist—found themselves cast in an oppositional role. Criticism of the status quo was more important to them than building up something new. And this tradition has persisted in western countries until today.

In his essay of 1925 entitled "Über proletarische Kultur" [On proletarian culture], K. A. Wittvogel distinguished between these two possibilities: art as a critique of the status quo and art as a vanguard of the new. Wittvogel ascribed them to opposing social systems.[85] Disagreeing with Trotsky, Wittvogel aligned himself instead with Lenin in affirming the existence of and the necessity for a lasting proletarian culture. It was important, however, "to

65 *Inflation*, 1921

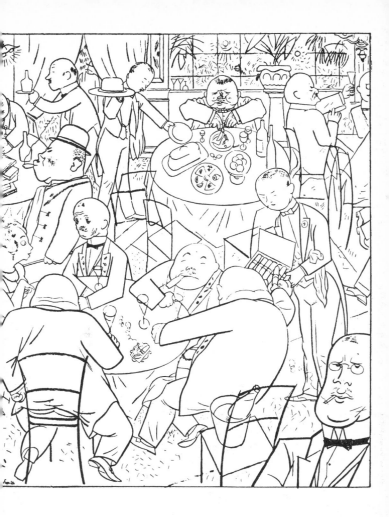

◁ 66 *My disability pay—* 67 = *a Havana cigar,* 1923

68 *If soldiers weren't so stupid, they would have run away on me long ago,* 1923

distinguish between proletarian culture before the proletariat had seized power and after." The "culture of the dictatorship of the proletariat" was, at least in part, "a constructive culture." "But proletarian culture within bourgeois society is a purely oppositional culture" because the means of production are still in the hands of the bourgeoisie.

The main question we need to answer about Grosz has to do with his motivation. Was it political from the outset and did it remain political for his entire career? Or was he first and foremost an artist rebelling against his society?

In a foreword he later wrote to *Trommeln in der Necht* [Drums in the night], Brecht discussed what interested Grosz in the subjects he chose to portray and drew some conclusions that proposed at least a tentative answer to this question.

Brecht started with the assumption that Grosz reacted to the bourgeois the way the bourgeois reacted to the proletarian when he reproached him for his sallow complexion. "I think what has made you an enemy of the bourgeois, George Grosz, is his appearance." Brecht did not believe that Grosz, "moved one day by overpowering sympathy for an exploited man or by rage against an exploiter, felt an irresistible urge to take up his pen and draw something on this theme." And Grosz, who always was inclined to cynicism, in fact did not have any great store of human sympathy. In this, he differed greatly from Käthe Kollwitz.

What remained was anger, but then we must ask whether it was anger alone that moved Grosz to wield his pen. Brecht went on to say: "I suspect that drawing entertained you and that the faces you saw gave you an opportunity to entertain yourself in this medium." We can hardly accuse Grosz of drawing just for entertainment. Even in his earliest work, it was clear that drawing was Grosz's way of coping subjectively with an oppressive environment. But we should not misunderstand Brecht here, either. Brecht was using the term "entertainment" as the opposite of political motivation. "I can imagine," Brecht went on to say, "that you developed a violent and irresistible passion for a certain typical visage one day and found that it had great possibilities for you as an artist. It was the 'Visage of the Ruling Class.' "

Brecht emphasized that he was by no means deprecating the delight in protest that moved Grosz to depict the "elite of humanity" as the "swine they are." But, he said: "You feel political

69 *I'll see that things are so bad in my territory that the people will think potatoes and thin beer are a holiday treat, 1922*

enmity for the bourgeoisie not because you are a proletarian but because you are an artist. Your political position . . . is your position in relation to your public (not in relation to your material)."[86]

Brecht's criticism was acute here and, I feel, correct. Grosz always reacted first and foremost as an artist despite all his verbal protestations to the contrary. He was not primarily a political being. Brecht's judgment did not detract in the least from the incisiveness of Grosz's pictorial statements. All it did was redefine the frame of reference of Grosz's work. The direction he took from the mid-1920s on confirmed Brecht's view of him. Grosz reacted to the war and the events of 1918–19 not as a proletarian and not as a revolutionary but as an artistic individual who stood in permanent conflict with the world around him and who gave expression to that conflict in pictures. His vision was critical but not partisan. Brecht went so far as to say that Grosz's political position was secondary in his work. In court again in 1924, to answer to and be convicted of a charge of blasphemy in *Ecce Homo,* Grosz himself described his work as "moralistic."

And indeed, starting in 1923 with *Ecce Homo,* Grosz did appear primarily as a moralist. Very few of the one hundred drawings in *Ecce Homo* were directly political in nature. The main thing Grosz did in this book was reveal the inner lives, the dreams, the passions, the longings and the rites of the young and the old, the rich and the poor, the prostitute and the beggar, the upright citizen and the loyal German. He presented a panorama of moral decay but did not go into causes and effects or argue from a Marxist position.

He simply showed the way things are. His methods were those of caricature, and the results therefore were not impartial. His work was clearly accusatory, but it was not social conditions that came under attack. It was the bourgeois himself, his features, his way of life, his erotic proclivities. In the *Ecce Homo* trial, Grosz said: "In my view, the great educational impact of this work derives precisely from the portrayal of depraved things, things we can assume will offend some people. . . . Everything in this book has a definite moral intent, even when I am depicting the crassest and ugliest things."[87]

Grosz had undergone still another profound transformation. In 1918–19, the misanthrope took up the cause of class struggle. A little later, the warrior of class struggle became a moralist.

70 *I'll destroy anything that prevents me from being absolute master here,* 1922

Consolidation and Contradiction (1924–32)

Art, Culture, and Politics

After brutally crushing the uprisings in the Ruhr and in Hamburg and after abolishing the workers' governments in Saxony and Thuringia in 1923, the Weimar restoration consolidated its hold over the country by enacting anti-inflationary and emergency measures. In the Reichstag elections of May 1924, the Communists as well as the right-wing parties, primarily the German National People's Party *(Deutschnationale Volkspartei)* and the Nazis, made great gains at the polls. And at still another Reichstag election held in December of the same year the government came under the control of a coalition between moderate and right-wing forces, despite the large number of seats the SPD was able to retain. In 1925, Hindenburg, the hero of Tannenberg, became president of the republic.

In the second half of the 1920s, many artists adopted a new line in their cultural and political activities. On the one hand, the cherished but illusionary hopes for a revolution subsided, as did the violent reactions to the counterrevolution, which had driven many artists and intellectuals into the leftist opposition. On the other hand, new organizations active in cultural politics and adhering to the line of a new firmly entrenched Communist Party sprang up. Grosz's work reflected both these developments.

Grosz continued to express his political commitment by taking part in protests and appeals to the public. As early as 1921, he was a signatory to an appeal issued by the Artists' Committee for the Relief of Hunger in Russia, an organization chaired by Piscator. In 1924, he took part in a similar appeal mounted by the International Workers' Aid Committee. In 1921, he joined Johannes R. Becher,

Dix, Otto Freundlich, Heckel, Hofer, Mühsam, Piscator, Zille and many others in protesting the abolishment of the eight-hour work day. The assassination of Walther Rathenau by right-wing radicals drew a protest from the same group in 1922. In 1925, Grosz joined other German intellectuals, writers, and artists in a statement of support for the Chinese people "in their struggle against imperialist exploiters." In 1926, along with Döblin, Eduard Fuchs, Heartfield, Magnus Hirschfeld, E. E. Kisch, Ernst Rowohlt and others, he took part in a campaign against proposed legislation to outlaw "filth and obscenity" and in another to dispossess German princes. (This latter measure was defeated in a nationwide referendum.) In 1927, he fought to preserve Vogeler's Barkenhoff frescoes in Worpswede and came to the defense of Erwin Piscator, the Berlin theater director, who was under attack at the time. In 1928, he signed a statement of support for Johannes R. Becher, who had been accused of high treason.

Whenever artists and intellectuals put aside their party differences to protest against injustice in the 1920s, Grosz was among them. Like the others who joined in signing one protest after another, Grosz doubtless felt that it was the artist's duty to act as a kind of conscience of the nation. He felt obliged to take public positions as well as carry on his artistic work. He made use of his fame as an artist to join with other like-minded prominent figures and act as a spokesman for all those who shared the same views but could not articulate them as clearly and to as broad a public.

Although Grosz did make election appeals on behalf of the Communist Party, he had little to do otherwise with its new cultural policies. Under Thälmann's leadership, the party had adopted a Leninist line and was developing a cultural policy to be implemented by party organizations. The Work Group of Communist Writers was founded in 1925. The Provisional National Committee of Worker-Photographers of Germany (it published a periodical called *Der Arbeiter-Fotograph* [The worker-photographer]) and Prometheus, Ltd., a company for the production and distribution of proletarian and socialist films, were both formed in 1926. World Film, Ltd., which was founded in 1927, produced its own weekly newsreel "World and Work." The People's Film Association (1928) included Heinrich Mann, Käthe Kollwitz and Erwin Piscator as members of its governing and advisory boards. Still other organizations were founded in 1928: the League of

Proletarian Revolutionary Writers of Germany (publication: *Linkskurve* [Turn to the left]), headed by Johannes R. Becher; the Workers' Theater League of Germany (publication: *Arbeiter-Bühne* [Workers' stage], renamed *Arbeiterbühne und Film* [Workers' stage and film] in 1930); and the Association of Revolutionary German Artists under the aegis of Becher, Kollwitz, Münzenberg, Otto Nagel, Ludwig Renn and others. In 1929, the Association for Promoting the Interests of Workers' Culture (*Interessengemeinschaft für Arbeiterkultur*—IfA) was founded along with its publication: *IfA-Rundschau* [IfA review]. This was an umbrella organization to coordinate the activities of the subsidiary groups. The IfA organized demonstrations, exhibits, concerts, theater evenings, lectures and discussions. Both professional and amateur artists frequently participated together in these cultural events. At the Berlin IfA exhibit sponsored in 1930 by the Association of Proletarian Freethinkers and the Militant Revolutionary Freethinkers, Grosz displayed a statue of Christ wearing a gas mask and army boots. The police promptly confiscated this "blasphemous" statue.

The Red Group

The Association of Revolutionary German Artists (now commonly referred to as Asso) modeled itself on the Red Group, an Association of Communist Artists which was founded in 1924 with George Grosz as chairman, John Heartfield as secretary and Rudolf Schlichter as executive director.

In its manifesto,[88] the Red Group said its purpose was "to work closely together with local Communist Party organizations to realize the following program and to contribute to an improved effectiveness of Communist propaganda":

1. Organize ideologically consistent propaganda evenings.
2. Provide practical help for all revolutionary cultural events.
3. Combat the remaining ideological influence of nationalistic thinking in proletarian cultural events (e.g., romantic nationalism as exemplified in some folk songs).
4. Provide art education at the local level (e.g., samples for posters; instructions for making signs, posters, etc. for demonstrations) and help party members improve their dilettantish efforts to express revolutionary desires in word and image.

5. Organize traveling exhibits.
6. Organize ideological and practical educational programs for revolutionary artists themselves.
7. Take public stands against counterrevolutionary actions and events in the field of culture.
8. Infiltrate and neutralize the bourgeois art world.
9. Exploit bourgeois art exhibits for propaganda purposes.
10. Approach students at art schools and win them over to the revolution.

The Red Group, which was founded by artists and intellectuals associated with the magazine *Der Knüppel* [The cudgel], was short-lived. We know nothing about its activities or Grosz's role in it. His chairmanship of the Red Group came at a time when he seemed more interested in integrating himself into the traditional art world than in adopting partisan cultural politics intent on opposing this art world and replacing it with new modes of communication.

Grosz presumably belonged to Asso, too, but unlike Hans and Lea Grundig, Otto Griebel, Wilhelm Lachnit (in Dresden), Alfred Frank (in Leipzig), and Otto Nagel and Heinrich Vogeler (in Berlin), he did not take any leading role in it.[89] Asso's program resembled that of the Red Group.[90]

Grosz's Theory of Art ca. 1925: Tendentious Art

In 1924–25 Grosz made the last of his theoretical statements that emphasized the social function of his art. These statements were much more moderate and less provocative than those he made in the years 1920 to 1923. In 1924, Grosz formulated his basic position in these terms: "Art is not a matter of aesthetics for me. Drawing is not an end in itself with no other meaning, not a musical doodling that can be appreciated and deciphered only by educated observers with overwrought nerves. Drawing must once again serve a social purpose."[91]

In a long article written with Wieland Herzfelde and entitled *Die Kunst ist in Gefahr* [Art is in danger] (Malik-Verlag, 1925), Grosz once again summarized his views on the function of art. This article was more retrospective than progressive and programmatic, more individualistic than partisan.

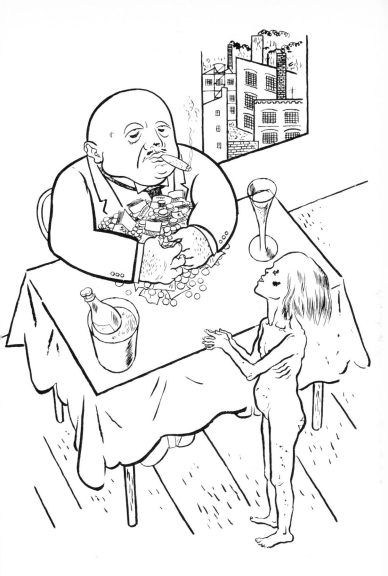

71 *Lions and leopards feed their young; even ravens serve up carrion to their little ones*, 1922

Die Kunst ist in Gefehr [Art is in danger] began with a polemic against the different schools dominating the art scene. Then Grosz went on to describe the way stations of his development: his misanthropic "people-are-swine" attitude, the refocusing of his hatred on war mongers, Dada as a reaction to the war,[92] and, finally, his identification with the revolution. "The great new task before us was . . . to create a tendentious art in the service of the revolutionary cause."

Going far afield, Grosz and Herzfelde next pointed out that "tendentious art" was nothing new, "that art has always been tendentious, and that only the nature of this tendentiousness and the clarity with which it was expressed varied." In search of examples, they took the reader on "a crash tour of art history." "If we reproach an artist for being tendentious, the reproach is justified only if the tendentiousness comes in conflict with the artist's true attitudes as subconsciously revealed in his style or if he tries to compensate for his lack of ability by interjecting a tendentious motif or adding a tendentious title." "If today's art lovers try to dismiss a tendentious work by calling it sensational or by claiming that all tendentious art is worthless, they are not objectively assessing the artist's work but are simply attacking the idea the artist is promoting."

Whether he likes it or not, the artist is in "constant interaction with the public and with society." If he does not take sides, he is automatically supporting the bourgeoisie. The shock of the abstract painters' "formal revolution" has long since worn off. "The modern bourgeois can digest anything." But anyone who pays more than lip service to the revolutionary cause will "see the value of his work in terms of its social usefulness and effectiveness, not in terms of individual artistic principles that cannot be tested against any objective standards."

A modern artist who does not want to "just mark time or be an outmoded dud" will have to become either an advertising artist or "a portrayer and critic" who reflects the times and fights "for a meaningful social order." It was obvious that Grosz was basically moving away from the ideology of class struggle or at least regarding it as only one of many options. He himself was tending more toward a reformist position and expressing a leftist liberal point of view that judged art primarily according to its "social usefulness and effectiveness."

72 *Right resides in the fist of the mighty,* 1922

Grosz defended "tendentious art" and justified it by claiming that all art is tendentious. He did not, however, justify it as the inevitable consequence of class struggle in a bourgeois society. Grosz's work in these years reflected this view of "tendentious art" and incorporated three major elements that followed from it: Verism as a tool to explore reality, social criticism of the bourgeois world and political satire serving specific causes. This last element, however, figured less and less prominently in the work of this period.

Grosz's Artistic Practice: Serving Two Masters

The *doppelgänger* idea that Grosz had expressed in 1915 receded into the background in the period immediately after the revolution, disappearing behind Grosz's sharp verbal statements. But now, in the mid-1920s, it emerged again both in his work and in the way that work was distributed. Grosz no longer belonged exclusively to the Communist camp but also to the bourgeois art trade, and the less he belonged to the one, the more he belonged to the other.

In 1923 and thereafter, Grosz had one-man shows regularly in the Galerie Flechtheim in Berlin as well as in a number of other major galleries. He had become a famous and successful artist. The tie with Flechtheim drew Grosz into the commercial art world that he had condemned for so many years.

In 1927, Grosz wrote in a letter: "My plan (with Flechtheim's help, of course) is this: I'll paint a series of saleable landscapes, i.e., landscapes with no objectionable figures in them. If they sell, I'll concentrate this winter on some big paintings I want to do, things like my *Eclipse* or *Pillars of Society* and so on. Courbet did this, too. He painted Lake Geneva over and over again for rich people."[93] The "objectionable figures" were eliminated for the time being in favor of "saleable landscapes."

While business was flourishing in Flechtheim's gallery with its upper-middle-class tone that Grosz had come to appreciate so much, he also was displaying his work in proletarian exhibits. In 1926, Otto Nagel proposed the idea of putting on special workers'

73 *Hitler the Savior,* 1923 ▷

74 *View of the City*, 1928–29

exhibits in department stores located in the working-class sections of Berlin, such as Wedding and Neuköln. Käthe Kollwitz, Heinrich Zille and other artists organized several such exhibits, and Grosz's work appeared in many, though not all, of them. His work was included in an exhibit of revolutionary western art held in Moscow in 1924 and in a Communist anti-war exhibit in Berlin in 1926. But by and large, Grosz's artistic interests had shifted. From 1926 on, Grosz did several series of illustrations, most of them with French motifs and lacking any kind of bite at all.

Grosz said to Count Harry Kessler in 1928: "I'm not satisfied with the real world. As what you might call an artistic nature, I'm out to find a fairy-tale world." Kessler commented on this remark in his diary: "Grosz seems to be turning away from reality altogether. He complained that our age reduces everything to rational terms and leaves no room for man's irrational needs."[94]

In 1925, Grosz stopped working for the satirical working-class magazine *Der Knüppel,* and a year later he began contributing to the thoroughly bourgeois periodical *Simplicissimus.* In the spring of 1927, when some critics were finding bourgeois traits in Grosz's work, *Die Rote Fahne* came to his defense, citing his "class hatred."[95] But in the fall of this same year, the magazine stated, with obvious disappointment: "The great satirist George Grosz has been politically silent for a long time."[96]

An analysis of Grosz's Veristic work and his collections of social and political drawings will illuminate these two divergent trends in his work from about 1925 on.

Verism

In 1922, responding to a questionnaire entitled "A New Naturalism?" sent out by the magazine *Das Kunstblatt* [The art paper], Gustav Friedrich Hartlaub wrote that he could discern a right and a left wing within the new anti-Expressionist movement.

> The one is conservative to the point of classicism and rooted in the timeless. After so much eccentricity and chaos, it wants once again to celebrate—in clear drawings done from nature—the healthy, the physical, and the plastic. If there is to be any exaggeration, it will be of the earthy and fully rounded shapes of nature. . . . The other wing is garishly modern because it sets less store by art and originates instead

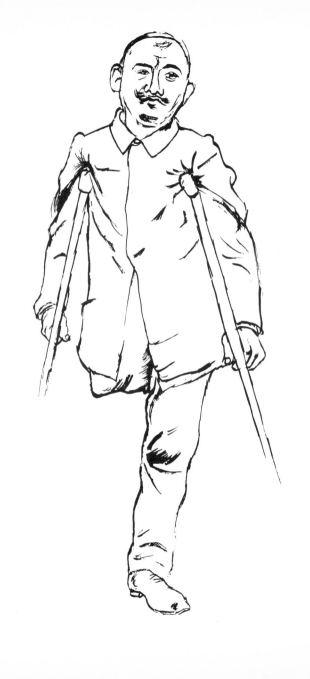

in a negation of art. Motivated by a primitive desire to report what is there and a nervous obsession to reveal the innermost self, it seeks to make chaos visible and to capture the true feeling of our time.[97]

In 1925, Hartlaub, who was director of the Mannheim museum, organized an exhibit there that he called "New Objectivity: German Painting after Expressionism." The exhibit included works by Beckmann, Davringhausen, Dix, Erbslöh, Fritsch, Grosz (Germany, A Winter's Tale and other works), Hubbuch, Kanoldt, Kretzschmar, Rössing, Räderscheidt, Schlichter, Georg Scholz, Schrimpf and others. Despite the fact that Hartlaub's catalog made a clear distinction between the left and right wings, between the "Verists" and the "classicists" (Franz Roh aptly dubbed them the "idyllists" in 1925[98]), the term "New Objectivity" was used indiscriminately for decades to describe artists as diverse as Kanoldt and Dix, Schrimpf and Grosz.

The long overdue distinctions between various styles within the "New Objectivity" were made only recently, in the catalog for the exhibit "Realism and Objectivity: Aspects of German Art from 1919 to 1933," held in East Berlin in 1974. This catalog divided the artists of this period into four major groups: the Verists, some of whom came from the Dadaist camp (Beckmann, Dix, Grosz, Hubbuch, Schlichter and G. Scholz); the New Objectivists (Franz Lenk, Carl Grossberg, Kanoldt, Räderscheidt, Schrimpf and others); the proletarian and revolutionary artists (Otto Griebel, Lea Grundig, Käthe Kollwitz, Otto Nagel and Curt Querner); and the political Constructivists (Gerd Arntz, Heinrich Hoerle, Oskar Nerlinger and Franz W. Seiwert).

The proletarian and revolutionary artists belonged to the Communist Party of Germany—or were closely connected to it—and eventually joined Asso. According to the exhibit catalog "Realism and Objectivity," they depicted human beings "as revolutionary subjects of history."

The idyllists of the New Objectivity offered romantic, escapist art as a counterweight to reality. Some of them remained in the good graces of the Nazis and retained their positions until 1936–37. The tradition of idyllic genre painting continued to be cultivated, though in a watered-down form, in official Nazi painting. The

◁ 75 *Cripple,* 1923

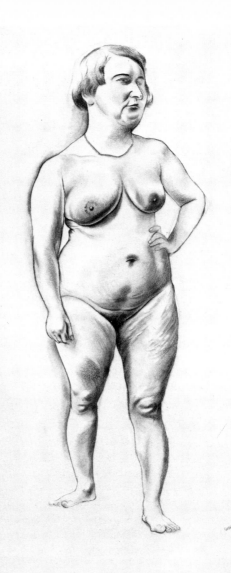

Verists, with their probing works, revealed the truth behind social conditions and occasionally suggested that those conditions could be changed. "The Verist," Grosz wrote in 1925, "holds a mirror up to his contemporaries' faces. I drew and painted out of opposition and tried, through my work, to show the world that it was ugly, sick, and hypocritical."[99]

The Verist and the realist often might use the same stylistic tools, presenting an exact representation of surfaces, but the essential difference between them lay in their subject matter. "Realism" cannot be understood as a stylistic term here but as an attitude toward reality. In this sense of the word, Grosz's painting *Pillars of Society* (Color Plate 7 — 1926) was both a realistic and a Verist work. Developing a theme he had presented in a drawing reprinted in *Das Gesicht der herrschenden Klasse* [The face of the ruling class] in 1921 and in *Germany, A Winter's Tale* (Illus. 53 — 1917–19), Grosz brought together personifications of the major forces that held the Weimar Republic together; the ex-fraternity man with his dueling scars, his saber, his beer mug and his Nazi stickpin; the fat German Nationalist with his head full of manure; the red-nosed clergyman who blesses everything indiscriminately; the ruthless, dogged military man, wielding his pistol and bloody sword; the reactionary journalist with a palm leaf in his hand and a chamber pot on his head. Count Harry Kessler reported in 1926, after a meeting with Grosz, that Grosz's ambition at this time was to do "modern historical paintings."

From 1925 on, Grosz produced considerably more paintings than he had before. He painted several major portraits in this period. Some of his subjects were his friends Felix Weil and Otto Schmalhausen, the writer Max Herrmann-Neisse (Color Plate 6), the art historian Eduard Plietzsch, and the boxer Max Schmeling. He also did several self-portraits (cf. Illus. 77). *Die Rote Fahne* described Rudolf Schlichter's portraits of Brecht, Egon Erwin Kisch, Helene Weigel and the prostitute Margot as "historical-materialist portraits" because the individual was shown as a product of social conditions.[100] The same could not be said of Grosz's portraits.

Grosz, who was self-taught as a painter, revealed his figures with great precision but glossed over some features. He was not intent

◁ 76 *Standing Nude,* 1924

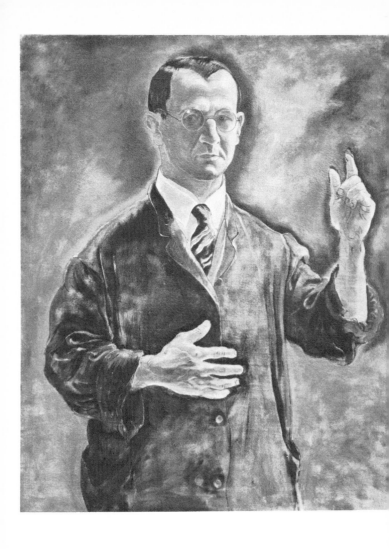

77 *Self-Portrait in the Role of Admonisher*, 1926

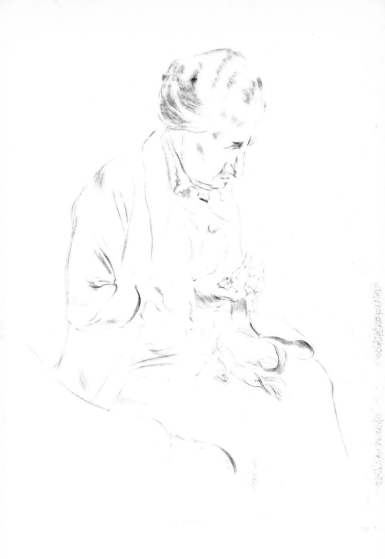

78 *Grosz's Mother*, 1925

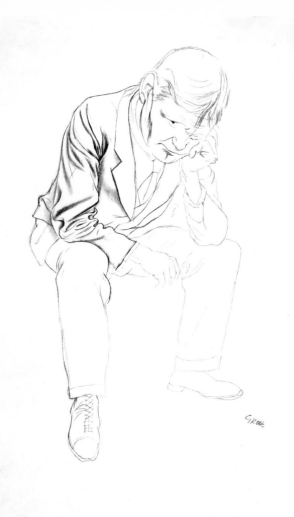

79 *Man out of Work,* 1924

on a dialectical presentation, and these paintings therefore were more in the style of the New Objectivity than of Verism. Where Schlichter conveyed substantial information about his subjects and revealed the complexity of their lives, Grosz tended to simplify and isolate his subject. The *Portrait of Max Herrmann-Neisse* clearly was an exception to this rule.

Apart from these paintings, Grosz also did a large number of pencil sketches of anonymous subjects. These drawings showed a great resemblance to the ones Schlichter did of the unemployed at this same time (cf. Illus. 79). Grosz's approach was atypically positive. These drawings of simple people reflected love, patience and sympathy.

In addition to these Verist and New Objectivist works, Grosz produced, at Flechtheim's urging, some very simple and "saleable" landscapes, cityscapes and still lifes. He also recorded his impressions of France in watercolors and sketches, continued his attacks on the German philistine and made occasional comments on current political events.

Social Criticism

Grosz published four collections of drawings between 1925 and his emigration in early 1933: *Der Spiesser-Spiegel* [A mirror for Philistines] (1925), and *Die Gezeichneten* [Marked men], *Das neue Gesicht der herrschenden Klasse* [The new face of the ruling class], and *Über alles die Liebe* [Love above all] (all in 1930). These drawings and Grosz's verbal statements from this period were characterized by profound resignation. "I raise my hand in a salute to the eternal law of human existence . . . and the sublimely indifferent immutability of life." This was the last sentence in Grosz's foreword to *Über alles die Liebe* [Love above all]. There was no mention anymore of change or the possibility of change.

Die Gezeichneten [Marked men] was made up entirely of works that already had been published elsewhere and dated back to an earlier period. *Die Spiesser-Spiegel* [A mirror for Philistines] and *Das neue Gesicht der herrschenden Klasse* [The new face of the ruling class] were aimed at contemporary types, caricaturing them and condemning them at the same time. Grosz's target was the philistine as such, regardless of his class origins (Illus. 80, 81). Only

in older drawings reprinted in these collections were class differences evident. In his foreword to *Der Spiesser-Spiegel* [A mirror for Philistines] Grosz named his new enemy. That enemy was no longer big capital or the military but "the compact majority, the brute stupidity of the masses." The revulsion for the masses that Grosz first expressed during the war emerged again here. Grosz did not inquire into causes and effects. He called himself a "moralist and satirist," who considered "drawing a useful weapon in the battle against our contemporary Dark Ages." "We still have tons of rubbish to cart away, and I'm happy to do my part in this work."

Grosz turned to general social criticism depicting the bourgeois world. His work lost much of its bite but did not gain in subtlety, either in its form or content, to compensate for that loss. Tucholsky's criticism in his review of *Die Gezeichneten* [Marked men] and *Das neue Gesicht der herrschenden Klasse* [The new face of the ruling class] was well-founded.

> George Grosz is a good friend of mine. He knows I'm not writing this for big capital. All I'm saying is that if he wants to deal a telling blow to an opponent, the way he did with his sergeants in generals' uniforms, he has to know that opponent thoroughly and capture every last detail of him. German bankers, IG Farben executives and mine owners don't look as overfed, fat-headed, and coarse as Grosz portrays them. They collect china; some of them have more finely modeled heads; as participants in this system and as far as the effects of their actions are concerned, they are inhuman. But this inhumanity is not evident at a first glance. They flock to Reinhardt's premieres, they vote for the German National Party they look different. Their appearance is more differentiated, three degrees finer. They're not better than Grosz shows them, just different.[101]

Grosz's drawings in this period are less precise and his targets more general. In 1927, Grosz wrote to Otto Schmalhausen with obvious malaise: "We've got to keep on playing the satyr somehow—there's still a lot of stupidity around. . . . After all, I wasn't born with a cloven foot for nothing."[102] In another letter to Schmalhausen, he said that the "reformer" and "polemicist" in him turned up from time to time,[103] but that he had "no philosophy."[104] He occasionally made anti-Communist statements, but they only emphasized the inconsistency of his position. As late as 1930 Grosz still was signing election appeals for the Communist Party of Germany.[105]

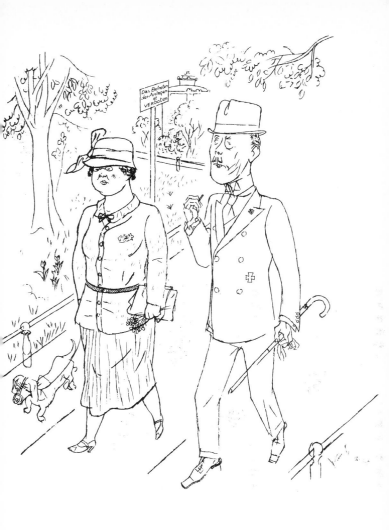

80 *A Mirror for Philistines,* 1925

Über alles die Liebe [Love above all] depicted couples from different social classes: the ill-matched (Illus. 82), the sophisticated, the poor, the shrewd, the bored, the professional, the knowing, the naive, the petit bourgeois, the hotshot. Undifferentiated representation took the place of analysis.

It is difficult, if not impossible, to pinpoint the reasons for this fundamental shift and the obvious consequences it had for Grosz's work. A number of factors were involved: The impulses Grosz received from the revolution were essentially emotional ones which then subsided in a way that truly political ones do not. Flechtheim's urgings and the attractions of the art market clearly affected Grosz, too. The consolidation in the Weimar Republic of forces left over from the days of the kaiser produced widespread resignation. Grosz's increasing estrangement from his close Communist friends who were going along with the Stalinization of the German Communist Party added to the uncertainty of his position. And, finally, Grosz's individualism and skepticism reasserted themselves.

Grosz's indecision and ambivalence were typical of many progressive bourgeois artists and intellectuals. If they did not have any clear political allegiance, they found themselves—in the last years of the Weimar Republic—more and more adrift between the social classes and, therefore, between the major political fronts. If they did not join one party or the other, they were isolated, without foothold or influence in society, despite all their joint actions and proclamations. They saw the fascist threat; but when everything they did to counter it proved futile, they were forced to recognize the ineffectiveness of their actions.

Grosz's attempt to escape the dilemma of the times took three forms. He turned to painting—art with a capital "A"—which he had so bitterly scorned only a few years earlier. He spent relatively long periods in France and so withdrew from dealing with the issues on a day-by-day basis. And he engaged in anarchistic actions, the purpose of which remained rather obscure. In a letter written from France in 1927, he said, "I started putting out broadsides signed *Der Drillbohrer* [The drill]. These leaflets consist of drawings accompanied by texts. They appear erratically and without imprint. . . . They are already circulating among the professional revolutionaries and in 'ultraleftist circles.' . . . *Der Drillbohrer* [The drill] is a loosely organized irresponsible association . . .

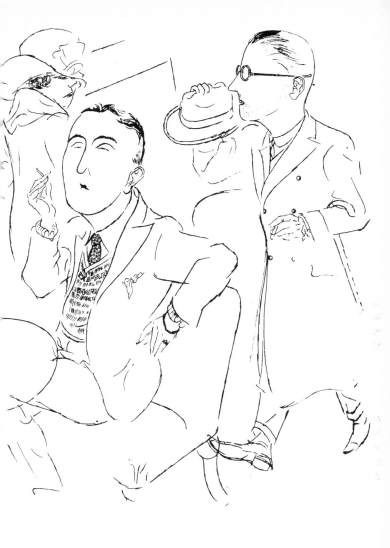

81 *A Mirror for Philistines*, 1925

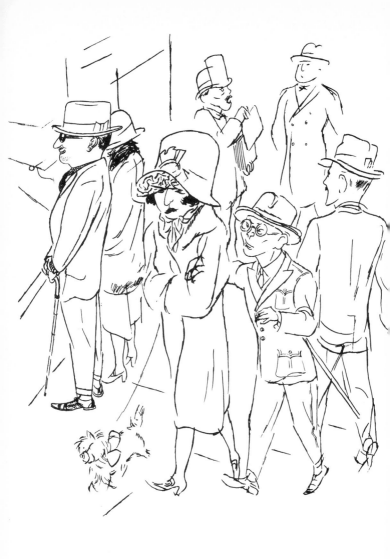

82 *From Hand to Hand*, 1930

intent on supplying the decorously stupid with arguments that will offend them and cast doubt on the infallibility of the 'saints.' " The leaflets were at odds with Russian policy. "They are meant to circulate from hand to hand and to violate certain 'guidelines.' "[106] The context made it clear that Stalinist "guidelines" were meant. From 1923 on, Grosz moved steadily away from the German Communist Party, and his alienation from it increased as the party became more and more Stalinist in character.

Public Reception: Right-Wing Praise for the Wrong Reasons and Rejection from the Left

The different levels of Grosz's behavior and work were reflected in its reception during the last years of the Weimar Republic. Grosz occupied a no-man's-land and was attacked by both the bourgeois and the leftists.

The triumphal tones of a review in *Kunst und Künstler* [Art and artists] were meant to accentuate a negative critique of Grosz's earlier work. Grosz finally had come to understand, the article said, that "talent is what ultimately counts . . . that art amounts to more than he used to think it did." "Something new" was beginning to appear "in this humorless unmasker of social atrocities." Unfortunately, he had "wasted a lot of time in tendentious art." He let himself "become one-sided, fanatical, even stupid." Now "the unpleasant aftertaste and the provocative element were disappearing" from his work. But Grosz would not be truly free until he understood "that true art does not consist of service to partisan politics but lies in the autonomy of talent."[107]

Eventually, this same critic found "a sense of duty," "something Prussian," and "academic self-discipline" in Grosz's work. He summed up by saying: "Young people are now taking a serious look into this mirror. Do they realize how hard Grosz is working 'to negate content through form'? And are they drawing the consequences for themselves?"[108]

In 1931, *Deutsche Kunst und Dekoration* [German art and decoration], which was by no means an extreme right-wing publication, called Grosz a "one-sided psychopath" who was "too maniacal, too fanatic, too filled with animosity" to be considered a successor of Daumier. His "ethical point of view" was "unfortunate," although he was "a master of form."[109]

The general political shift to the right expressed itself repeatedly and emphatically in response to Grosz's work. When the November Group celebrated the tenth anniversary of its founding with a retrospective exhibit, *Kunst und Künstler* [Art and artists] wrote: "Dix's *Barricade* and Grosz's *Winter's Tale* are, a mere ten years later, no more than curiosities that belong only in a collection of mementos from the time of the revolution. Political conviction alone does not produce art."[110]

Die literarische Welt [The literary world] was more discriminating in its opinion: "The delight many art lovers are feeling over the fact that this aggressive Spartacist has been converted to the cult of fine nuances overlooks how much cold disgust shows through the lavish irridescence of his new tones."[111]

Die Rote Fahne wrote in 1927 that bourgeois critics were beginning to feel obliged to welcome Grosz into their camp on the basis of his new works. But, the magazine went on, Grosz had "nothing to do with the lie of the so-called 'New Objectivity,' which copied insignificant details with pedantic accuracy, diligently avoiding the larger context and the exposure of social problems." It was true, of course, that Grosz seemed "reluctant" at present "to work as a journalistic and political artist." Grosz knew very well "that a drawing, no matter how politically correct and journalistically sharp it may be, is of no use if it does not fulfill its immediate propagandistic purpose."[112]

In 1927, *Die Rote Fahne* praised *Pillars of Society* as "an accurate cross section of the German republic."[113] But in 1928, the magazine saw Grosz's new efforts, on the whole, as "transitional works of this great satirist,"[114] finding in them the "bleak colors of bourgeois decline, a languid decay. These works are unlikely to stimulate the imagination."[115]

By 1931, Grosz had become a historical figure. "No other German artist used art as a weapon as effectively and deliberately as George Grosz did during the German workers' struggle for liberation from 1919 to 1923. He is one of the first artists in Germany who defined art as tendentious and placed it in the service of the revolutionary cause. The drawings collected in the two volumes *Das Gesicht der herrschenden Klasse* [The face of the ruling class] and *Abrechnung folgt!* [Accounts to be settled] not only speak to us directly today but are also timeless documents of proletarian and revolutionary art."[116]

83 *Hot Shots,* 1930

The critical reception Grosz received no doubt contributed to his withdrawal from public life. The bourgeois critics overvalued his gallery work at the expense of his socially critical work, and the leftist critics showed a continuing interest only in his older work. It cannot be denied, of course, that Grosz himself—both in his behavior and in his work—helped evoke this divided response.

The State vs. Grosz

Almost every year from 1920 on, Grosz designed the sets, costumes or both for at least one Berlin theater production. At first, he often collaborated with John Heartfield on this work. In 1926, he did his first set for Erwin Piscator. The play, put on in the Berlin Volkstheater on Bülowplatz, was Paul Zech's *Des trunkene Schiff* [The drunken ship].

In 1928, Grosz did a cartoon film for Piscator's production of *The Good Soldier Schweik* at the Theater am Nollendorfplatz. The film, incorporating several hundred drawings based on scenes from Hašek's play, was projected onto a backdrop.

Grosz gave this account of his work with Piscator:

> Erwin would simply set up a huge drawing board covered with white paper at the back of the stage. I commented on the action, using huge hieroglyphics. I moved up and down in counterpoint, underscoring the text or actually drawing in the most delicious and essential comments and Hašekian barbs that went unsaid on the stage. . . . What an opportunity for an artist who wants to address the masses. A new medium, of course, requires a new style: a new, clear, spare mode of drawing. . . . In a film, the line has to be clear, simple and not too light (because of fade-ins and fade-outs). It also has to be strong, like the drawings and woodcuts in Gothic block-books and the figures cut into the pyramids.[117]

In the same year that the hugely successful *Schweik* production was running (with Max Pallenberg in the leading role), the Malik-Verlag published seventeen drawings from the film in a small portfolio called *Hintergrund* [Backdrop]. The second drawing (*Be Obedient to Authority* — Illus. 84) attacked the alliance among the military, the church and the legal system. The ninth (*Dividends of the Holy Ghost* — Illus. 85) pilloried the warmongering of the

seid untertan der Obrigkeit

84 *Be obedient to authority,* 1928

church. The tenth *(Keep your mouth shut and do your duty* — Illus. 86) showed Christ on the cross, wearing a gas mask and army boots. These three drawings prompted the most spectacular blasphemy trial that ever had taken place up to that time.[118]

Because these drawings, "by themselves and in conjunction with their captions," might constitute "public slandering of institutions of the Christian churches," the district attorney for the Charlottenburg Local Court, at the request of the commissioner of police, applied for permission to confiscate the portfolio *Hintergrund* [Backdrop]. The court granted permission instantly. Grosz was interrogated. In his statement, he said, "I vigorously protest the allegation that I intended to defame the church or to be blasphemous in these drawings." A few days later the portfolios were confiscated in leftist bookstores in Berlin and elsewhere.

In May 1928, formal charges were entered against Grosz and his publisher Wieland Herzfelde. Grosz already had two convictions on his record, one for "insulting the German army" in 1921 in the portfolio *Gott mit uns* [God on our side] and one for "circulating

obscene pictures" in 1924 in *Ecce Homo*. The Association of German Writers stepped in and demanded acquittal. These drawings, the association claimed, amounted to "a new document bearing witness to a freedom-loving philosophy born of a profound ethos and the passion of true conviction."

In December 1928, the Local Court in Moabit fined Grosz and Herzfelde 2,000 marks each. The court's decision said that "the gas mask and soldier's boots, taken together with the words attributed to Christ in the caption, constitute a crass and derogatory expression of disrespect for a symbol honored by many. They constitute, in other words, a slandering of institutions of the Christian religion."

The case was reheard in April 1929 on an appeal entered by the attorney for Grosz and Herzfelde. The Second Criminal Chamber of Regional Court III, Berlin-Moabit, acquitted Grosz and Herzfelde. In its decision, the court said it was Grosz's intention "to fight against the idea of war and to attack any actions on the part of the church that lend support to the idea of war." "This cannot be construed as a violation of religious sentiment," because, "just as all members of society have to accustom themselves to the particularly harsh forms of criticism that our time fosters, so members of religious communities have to take this into account." If this were not the case, "it would be impossible for art to fulfill its cultural mission in national life."

The next day, the prosecutor appealed. In February 1930, the Second Criminal Senate of the National Court reversed the decision and sent the case back down to the Regional Court for retrial. The Senate found that "to the honest sensibility of a simple religious man," Grosz's drawing would appear blasphemous indeed.

A large number of expert witnesses were summoned for the retrial in the Moabit Regional Court in December 1930. Among them were Quakers and representatives of Catholic and Protestant churches. Grosz and Herzfelde were acquitted again.

And once again the prosecutor appealed, and once again the case was heard before the National Court. The decision of November 1931 read: "The drawing Nr. 10 *(Keep your mouth shut and do your duty)* from the portfolio *Hintergrund* [Backdrop] published by the

85 *Dividends of the Holy Ghost, 1928* ▷

Die Ausschüttung des heiligen Geistes

Malik-Verlag and all copies of this drawing now in the possession of the author, the printer, the editor, the publisher, or any booksellers and any copies publicly displayed or publicly offered for sale as well as the printing plates for the drawing will be rendered unusable."

In 1932, the Berlin police commissioner reported to the public prosecutor that not all existing copies of the drawing could be "rendered unusable." The "portfolios contained in cartons that the police had sealed shut and impounded" at the Malik-Verlag in 1928 "had been sold in the meantime and were no longer available." Wieland Herzfelde had played a little trick on the authorities. A criminal complaint was lodged against Herzfelde. And only now did the authorities ascertain that the Malik-Verlag had had no further use for the printing plates for the offending drawing once the portfolio had been printed and therefore had destroyed the plates right away.

The trial received massive coverage in the press and evoked a widespread public response. The Association against Censorship, the German League for Human Rights, the National Artists' Association, and a large number of individual writers and artists, such as Walter Mehring, Kurt Tucholsky and Carl von Ossietzky, joined in the protest. Commenting on the trial years later, Günther Anders wrote: "Not only had the drawing become part of reality now, but reality had also become part of the drawing. Not only did the drawing depict reality, but reality depicted the drawing."[119]

The Grosz trial was not an isolated case in the Weimar Republic. Works were banned, censored, and confiscated; artists and writers were tried and jailed. Among the many individuals affected were Johannes R. Becher, Willi Bredel, Brecht, Tucholsky, von Ossietzky and Friedrich Wolf. The Malik-Verlag, of course, was a favorite target. Wieland Herzfelde reported that in the years up to 1929 twelve Malik-Verlag publications—six of them by Grosz—had been confiscated.[120]

On assuming the chancellorship of Germany in 1932, Franz von Papen announced a campaign against "cultural Bolshevism" as part of his government's policy. It had long been obvious that the authorities' harassment of artists and writers amounted to political measures against dissenters. The Weimar Republic was on the verge of becoming the Third Reich. The last item in the file from the

86 *Keep your mouth shut and do your duty,* 1928

Grosz trial is a letter, dated October 17, 1933, from Goebbels'
ministry to the prosecutor of the Superior Regional Court, asking
that the drawing *Keep your mouth shut and do your duty* "be made
available for a brochure dealing with cultural Bolshevism."[121]

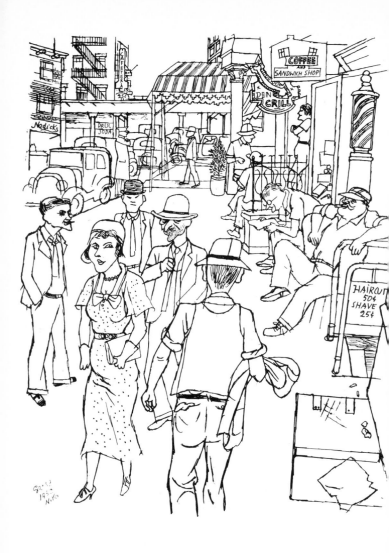

87 *New York,* 1932

Emigration (1933–59)

The Realization of Grosz's American Dream

As early as 1927, Grosz wrote in a letter: "I'm going to leave Germany for a while."[122] And in the same year, Grosz's friend Tucholsky explained to Maximilian Harden why he, too, had decided to leave Germany. "Germany—as I hardly need tell you—is not a very friendly place to be. I can't take much pleasure in life here, and I'm afraid that my work shows it. If you don't happen to be vain and self-righteous, it's not much fun to do what I've had to do—unless you feel a particular calling in this line. And in the year 1927, I can't exactly say I feel that calling."[123] Grosz must have felt much the same way. In a letter of 1932, he wrote that he was going to leave Germany not because he hated it but because there were no possibilities left there for an artist of his stature.[124]

"It's not worth it," Tucholsky said. "There's no hope of bringing the Communist Party and the SPD together to make common cause against fascism. That's been tried over and over again. They're all so caught up in their party machinery—they can't see past their trivial party affairs—what good can somebody like me do with the likes of them?"[125]

They abandoned ship, leaving Germany before the Nazi assumption of power: Tucholsky and Herwarth Walden, Bela Balàzs and George Lukács, Erich Maria Remarque and Carl Einstein, and many others. In 1932, Grosz accepted a very welcome invitation to be a guest professor at the New York Art Students' League for a few months. He returned to Germany briefly, then settled permanently in the United States in early January 1933, just before the Nazi takeover. The move came just in time. "I was soon getting letters telling me that the authorities had come looking for

me in my now empty apartment and studio in Berlin. It's unlikely I'd be alive now if they had found me there."[126] Grosz was one of the first to be stripped of his citizenship right after the Reichstag fire.[127]

Grosz's decision to leave Germany probably was not just a political one, not just a decision against Germany, but also one for America. Resignation and hopelessness (Color Plate 8) heightened his longing for a fresh start, a new life. His youthful dreams about America came alive again. He saw "a chance to realize this long-harbored wish." His first impressions during his brief stay in 1932 were basically positive. "I liked New York. I found the city to be just the way I had imagined it. My wish had come true" (Grosz).

Grosz was fascinated by the New York types that he tried to capture in a number of drawings and sketch books. He was intrigued by the nonchalance of Americans, the tempo of life, the fashions, the shows, Broadway, and Forty-second Street. In one of his reports and letters from America that were published in German magazines in 1932 and early 1933,[128] he wrote: "Today I received your card from beautiful Stolp in Eastern Pommerania. Yes, I remember those days, and I can still see myself as a boy wandering around there, watching those big gold and white circus trains that fed my romantic yearnings for America pull into the station. Well, here I am now, sitting among these mountain ranges of skyscrapers and thinking back on those times, and it seems just right to me to be spending some time here."

Old and New Material

In this period, Grosz's assessment of his own artistic work, particularly that done at the peak of his political commitment, began to shift. "I was still interested in politics at that time, but my faith in the masses had already begun to crumble, which is to say, if I am honest, that I questioned the 'missionary value' of my art. I had gradually come to see that the effectiveness of this kind of propaganda had been grossly exaggerated. . . . My disillusionment

◁ 88 *New York Types,* 1934

came gradually but inevitably. It was one of the factors that made it so easy for me to leave Germany." This statement, from Grosz's autobiography of 1946, should not be interpreted as a retrospective falsification of the facts induced by the anti-Communism prevalent in America. Grosz's letter from around 1933 show that his views had changed drastically since the mid-1920s and that he had completely abandoned the convictions he held at the time of the revolution.

In harsh remarks to Wieland Herzfelde, he stressed time and again that the Communists were not intrinsically different from the fascists. Grosz was turning his back on his political and artistic past for the sake of a new present. "My bitterness was so extreme that I decided to leave everything behind me and forget who and what I had been. In short, I wanted to start an 'American' life."

But this conflict with his own past raised problems in the new American life he wanted to lead in the present. "The people who knew of me here admired me as a satirist. The side of me they valued was the cartoonist who had responded to his fellow human beings by making fierce, bitter faces. Almost everyone thought my best years had been the ones when I had been a harsh critic of the postwar German world. For many people, I had almost become a legend. I was a leftover from an earlier age" (Grosz).

Bitterness and withdrawal followed on deep disappointment. Grosz questioned the validity of his entire life's work because all his polemical and moralistic efforts had not been able to halt the rise of National Socialism. As Grosz himself said in an interview in 1958, he had become a satirist "after an illusion had broken down. What really collapsed at that time was the bourgeois world, the Victorian age. That was in 1914. Then the war came. I had to strike back." He had thought his satirical drawings might have a purifying and preventive function. "When Hitler appeared, I felt like a boxer who had lost. Everything we had done had been done in vain."[129] Grosz's final rejection of the principles of political satire was a product of despair. The *raison d'être* of his work had been to improve society, but he felt he had failed utterly in this attempt. This is why he was trying to begin a new life now and make a fresh start as an artist.

Grosz wanted to become an American illustrator, and he had some success in placing his drawings in *Esquire* and in *The New Yorker*. But the Americans did not want this new illustrator who

89 *Stones and Rocks*, 1935

approved of his surroundings. They wanted the old Grosz, the bitter satirist. But true satire springs from both hate and love. Grosz admired America and the Americans. He was not close enough to them to love and hate them from the very depths of his being. The basis for satire was lacking. At the same time, he was burning his bridges behind him. Wieland Herzfelde had, in the meantime, emigrated to Prague and set up his publishing business again there. Grosz now asked Herzfelde not to use any more of his material in Malik-Verlag publications.

"The artist in me came to the fore." Grosz now assigned a lower status to caricature and satire, which he had seen around 1920 as the only suitable artistic vehicle for propagating ideas, and ranked them far below "art." "When I worked with political and social

satire in the past, I was always conscious of its restrictive nature. By limiting himself to the satirical representation of current events, of the comedies and tragedies of the moment, the artist is like a fiddler who scratches about on too small an instrument. Great art has little use for the scorn and barbs and allusions of the satirist. With all due modesty, I hereby offer evidence that I have outgrown the satirical phase in my artistic development."[130]

Like many others, Grosz suffered from the hardships of emigration. He was cut off from his own tradition and surroundings, from his native language, from a familiar social environment, from his friends. He tried to compensate for this by trying hard to assimilate himself into American society. But he could not break completely from his own past. Trying to emanate optimism despite his depressions, he was a broken man or, as Hans Hess called him, a "lonely drinker." As Grosz said of himself during this period: "For some reason I could not achieve the simplicity and normality that I admired so much in American illustration. I could never quite capture that clarity. . . . The faces I drew turned out looking medieval and uglier than I wanted" (Grosz).

He sought refuge in art, especially art depicting nature. But his landscapes and nudes only brought disapproval from his old friends down on him. Felix J. Weil, a patron from earlier times and the founder of the Frankfurt Institute for Social Research, wrote Grosz in a letter that he was profoundly disturbed to see that Grosz had become an American "conformist." Weil said he would be able to understand if Grosz had been forced to do nudes, landscapes and still lifes because he needed the money, but that was apparently not the case. Grosz seemed to really believe in this "swindle."[131] Grosz replied that the success of his earlier drawings had had nothing to do with their content, and he sang the praises of painting and of the old masters.[132] A few months later he wrote that he always had been, in his heart of hearts, a classicist and a romantic.[133]

It is difficult but essential to understand this reversal as it relates to political developments in the late Weimar Republic and, finally, to Grosz's exile.

We have to keep in mind that Grosz, although he may have wanted to see himself as a romantic, did not create a unified work in the 1930s. Despite all his efforts to paint in the style of the old masters, his work remained many-faceted. Along with nudes and

90 *School,* 1935

landscapes, he also produced works inspired by social and political events.

In his autobiography, Grosz said of this period in his life: "I was keenly intent on imitating the great Walt Whitman, who once wrote:"

> Do I contradict myself?
> Very well then I contradict myself,
> (I am large, I contain multitudes).

This may well be the key to understanding Grosz's artistic personality and work. Only for a brief period around 1920 did the multiplicities and self-contradictions recede or temporarily disappear. Everything else that Grosz ever painted, drew or wrote is

183

marked by multiplicity and self-contradiction. We see this quality emerging about 1915 in the *doppelgänger* idea, continuing in Grosz's double life as a gallery painter and social critic in the mid-1920s, and persisting for the rest of his life.

Grosz's work grew out of this conflict. He offered no ultimate solutions but only stated the problem of the artist in relation to his specific environment. His work mirrored the upheavals of the war, his hopes for the realization of utopia during the revolution, his rage over the destruction of these hopes, his resignation in the face of reactionary trends in the Weimar Republic and the rootlessness of his life in exile. The contradictions and multiplicity of Grosz's work did not resolve problems; they accentuated them.

In the '30s and '40s, Grosz produced a body of work that bore no relationship to his landscapes and nudes. Grosz called these works "apocalyptic pictures" or "pictures of hell." They depicted death, despair, and catastrophe. Making use of Expressionist methods and symbolic pictorial elements, Grosz evoked the end of civilization and showed man unable to find his way out of the devastated cities and landscapes. Grosz often portrayed himself in this situation as a lost *Wanderer* (unreproduced painting—1943). Grosz frequently mentioned that he had come to agree with Swedenborg's view that hell already existed on earth.

News of the terrible mistreatment and death of his old friend Erich Mühsam at the hands of the Nazis and the reports of his friend Hans Borchardt, who had escaped from a concentration camp, prompted Grosz to do some drawings and watercolors depicting torture and persecution. Here, as in the work of the mid-1920s, Grosz put considerations of beauty aside and developed a drastic, unambiguous visual language that not only described but also sharply condemned the inhumanity of the Nazis.

"Degenerate Art"

As early as 1929 and 1930 the Combat League for German Culture, headed by Alfred Rosenberg, was railing indiscriminately against Grosz and Tucholsky, Brecht and Thomas Mann, Klee and Beckmann, Nolde and Dix. In 1933, the Nazis staged their first exhibits aimed at discrediting contemporary artists. Grosz was among the artists shown in the Stuttgart exhibit "The Spirit of

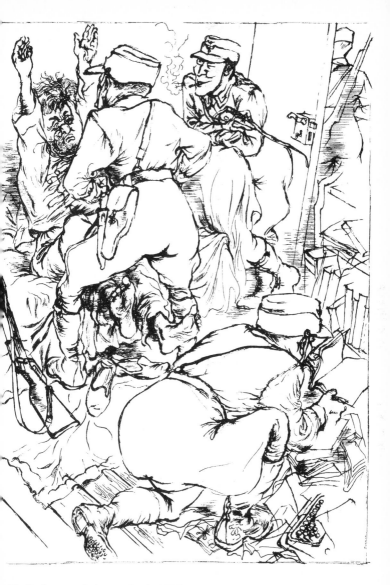

91 *So he says he's a writer?*, 1935

November — Art in the Service of Dissolution" and in a comparable exhibit in the Mannheim museum (Gustav Hartlaub already had been fired from his post as director). In a letter of 1933, Grosz wrote that he was secretly proud to be included in these exhibits because it proved that his art had not been pointless after all and that it had revealed the truth.[134]

At the exhibit "Degenerate Art" held in Munich in 1937, five oils by Grosz (among them the portraits of Max Herrmann-Neisse and Max Schmeling), two watercolors, and thirteen prints were displayed. A total of 285 works by Grosz were removed from German museums, and when thousands of art works were burned in 1939, a large number of Grosz's works were among those destroyed.

More than 20,000 people visited the Munich exhibit every day. But, as Paul Ortwin Rave said in 1949, "There is no point in trying to tell ourselves that some few of them perhaps came to say goodbye to works of art they loved. It is clear that the propagandistic purpose of dealing a death blow to the genuine art of the present had essentially been accomplished."[135]

Return

In the catalog of a 1946 exhibit in New York that focused primarily on Grosz's work done in exile, Grosz wrote: "I don't know how much my pictures have to do with a dubious 'reality.' And in fact that reality interests me very little. My pictures bear witness to my inner world."[136]

Most of Grosz's paintings from 1946 on were of an allegorical figure he called the "stickman." This artificial figure, a human being without substance, was shown being subjected to oppression and destruction or as a survivor barely escaping with his life in a world of ruins. The extent of Grosz's pessimism was evident in a figure he devised in 1947–48: the "painter of the hole." This painter, a stickman, was not able to paint anything but a hole. The negation Grosz was trying to depict was fully realized in this allegory of nothingness.

92 *Stickmen,* 1946 ▷

Drained, unhappy, often drunk, Grosz saw his American dream come to naught. He had not been able to establish and build a reputation either as an illustrator or a painter. He taught at the Art Students' League in New York starting in 1932; at the Sterne-Grosz School in New York starting in 1933; at his own private school in Douglaston, Long Island, starting in 1936; and at Columbia University starting in 1941. But teaching was not really satisfying for him, and what he earned from it was barely enough for him to live on.

When he was offered a professorship at the Berlin Academy in 1947, he refused it. The reason he gave, in a personal letter, showed how shattered he was. He wrote that he preferred being poor and a failure in America to being a failure and poor in Germany.[137]

In 1954, he visited Europe and Germany for the first time since the war, but "after a visit to Berlin, I fled."[138] He went to West Germany once again in 1954 in connection with the German publication of his autobiography *Ein kleines Ja und ein grosses Nein (A Little Yes and a Big No)*. In 1959, 26 years after leaving, Grosz returned to Berlin. His American dream had exploded like a soap bubble; but, as he wrote in a letter of March 1958, it had been a beautiful, iridescent bubble while it lasted.[139] On May 29, he followed his wife Eva to Berlin. His two sons, Peter and Martin, were American citizens and stayed in the United States. Grosz wanted to make a fresh start. On the night of July 5, just before his sixty-fifth birthday and barely six weeks after his return, he fell down a flight of stairs and choked to death after leaving a bar.

Notes

I am grateful to Charlotte Schmalhausen and Willi Wolfradt for information about Grosz, and I am particularly indebted to Martin O. Grosz and Peter M. Grosz for the ready assistance they gave me in examining Grosz's literary records. *Uwe M. Schneede*

1 George Grosz, *Ein kleines Ja und ein grosses Nein (A Little Yes and a Big No),* (Reinbek: 1974 [first published in New York, 1946, and Reinbek, 1955]). The short title "Grosz" is used in the text to refer to this autobiography. The part of the autobiography dealing with the period before World War I is a revised version of Grosz's "Jugenderinnerungen" [Recollections of my youth], *Das Kunstblatt* [The art paper], XIII, Nos. 6–8 (1929) and "Lebenserinnerungen" [Reminiscences], *Kunst und Künstler* [Art and artists], XXIX (1930), both of which appeared serially in these periodicals.

2 Sigmund Freud, "Der Dichter und das Phantasieren" [Creative writers and day-dreaming] in *Sigmund Freud,* Studienausgabe [Student edition], 10 vols. (Frankfurt am Main: 1969ff.), X, 173f.

3 Hans-Friedrich Foltin, *Nick Carter: Amerikas grösster Detektiv* [Nick Carter: America's greatest detective], reprint (Hildesheim and New York: 1972), I, vi.

4 Karl Markus Michel, "Zur Naturgeschichte der Bildung" [On the natural history of education], *Trivialliteratur* [Popular literature], ed. G. Schmidt-Henkel, H. Enders, F. Knilli, and W. Maier (Berlin: 1964), p. 15.

5 *Das Kunstblatt,* XIII, No. 6 (1929), pp. 166–174; XIII, No. 7 (1929), pp. 193–197; XIII, No. 8 (1929), pp. 238–242.

6 Grosz, *Der Spiesser-Spiegel* [A mirror for Philistines], (Dresden: 1925), foreword by Grosz.

7 Thomas Schröder, "Der Abgrund in Herrn Müller" [The abyss in Mr. Müller], *ZEIT-Magazin,* No. 45, Nov. 1, 1974, pp. 67–75.

8 My account is based in part on research done by Alexander Dückers in *George Grosz, Frühe Druckgraphik 1914–1923* [George Grosz: early graphics 1914–1923], exhibit catalog, West Berlin (Staatliche Museen Preussischer Kulturbesitz, Kupferstichkabinett) 1971.

9 Letter to Robert Bell, written in late September 1915 from Berlin.

10 Letter to Robert Bell, 1916.

11 Letter to Otto Schmalhausen, March 15, 1917.

12 Letter to Otto Schmalhausen, June 1, 1917.

13 Letter to Otto Schmalhausen, December 17, 1917.

14 Grosz, *Ein kleines Ja und ein grosses Nein* (2nd ed.; Reinbek: 1974).

15 Grosz, "Abwicklung" [Development], *Das Kunstblatt,* VIII, No. 2 (1924), p. 36.

16 Letter to Otto Schmalhausen, April 22, 1918.

17 Grosz, "Abwicklung," p. 36.

18 Letter to Robert Bell, late September 1915.

19 Letter to Robert Bell, late 1915 or early 1916.

20 Letter to Robert Bell, 1916.

21 Grosz, "Abwicklung."

22 Grosz, *Ein kleines Ja und ein grosses Nein.*

23 Grosz and Wieland Herzfelde, *Die Kunst ist in Gefahr* [Art is in danger] (Berlin: Malik-Verlag, 1925).

24 Grosz, *Der Spiesser-Spiegel,* foreword.

25 Grosz, "Man muss Kautschukmann sein" [You've got to be a man made out of rubber], *Neue Jugend* [New youth], II, No. 8 (1917).

26 Richard Huelsenbeck, *Dada siegt! Eine Bilanz des Dadaismus* [Dada victorious! An assessment of Dadaism] (1920), pp. 28f.

27 Herzfelde, *Immergrün* [Evergreen] (Berlin and Weimar: 1969), p. 177.

28 Walter Mehring, *Berlin Dada* (Zurich: 1959).

29 Paul Westheim, "Legenden aus dem Künstlerleben" [Tales from the artistic life], *Das Kunstblatt,* XVI (1931), p. 149.

30 Reprinted in *Künstlerbekenntnisse* [Artists' Confessions], ed. Paul Westheim (Berlin, n.d.), pp. 304–308.

31 Robert Breuer, "George Grosz," *Die Weltbühne* [World stage], Feb. 10, 1921.

32 *Neue Jugend,* I, Nos. 11–12 (1917), p. 242.

33 *1918: Neue Blätter für Kunst und Dichtung* [1918: new review of art and literature], I (1918), p. 154.

34 Kurt Tucholsky, *Gesammelte Werke* [Collected works], 3 vols. (Reinbek: Hamburg, 1960), II, 1065.

35 Prospectus for *Neuer Jugend* (1916).

36 Letter to Robert Bell, late September 1915.

37 Huelsenbeck, introduction to *Dada-Almanach* (Berlin: 1920).

38 Huelsenbeck, *Dada siegt!*

39 *Die Zwanziger Jahre. Manifeste und Dokumente deutscher Künstler* [The 1920s: manifestoes and documents by German artists], ed. Uwe M. Schneede (Cologne: 1979), pp. 20–22.

40 Huelsenbeck, *En avant dada. Die Geschichte des Dadaismus* [En avant dada: the history of Dadaism] (Hannover: 1920).

41 Grosz, "Abwicklung."

42 Grosz, *Die Kunst ist in Gefahr* (Berlin: 1925).

43 *Die Zwanziger Jahre. Manifeste und Dokumente deutscher Künstler,* pp. 20–22.

44 Count Harry Kessler, *Tagebücher 1918–1937* [Journals 1918–1937] (Frankfurt am Main: 1971).

45 Grosz, "Moja Žizn" [My life], *Prožektor* (Moscow), VI, No. 14

(1928), cited according to Beth Irwin Lewis, *George Grosz: Art and Politics in the Weimar Republic* (Madison: 1971).

46 There is some debate as to whether Grosz was a member of the Communist Party of Germany or not. Charlotte Schmalhausen, Grosz's sister-in-law, claims that he was. Peter M. Grosz, Grosz's son, claims he was not. Paul Reissert shares this view in the exhibit catalog *Neue Sachlichkeit* [New objectivity], Kunstverein Hannover (Hannover: 1974). In a statement to the FBI, however, Grosz himself said he had been a member. Cf. Hans Hess, *George Grosz* (London: 1974), p. 247.

47 *Die Zwanziger Jahre. Manifeste und Dokumente deutscher Künstler,* pp. 72, 73.

48 Adolf Behne, in a special issue of *Novembergruppe* [November group], II, No. 14 (1919).

49 Letter from Walter Gropius to Karl Ernst Osthaus, December 23, 1918, cited according to Wolfgang Pehnt, *Die Architektur des Expressionismus* [The architecture of Expressionism] (Stuttgart: 1973), p. 89.

50 "Ja!—Stimmen des Arbeitsrates für Kunst in Berlin, 1919," *[Yes!—Voices of the workers' Soviet for art in Berlin,* 1919] reprinted in *Manifeste, Manifeste* [Manifestoes, manifestoes], ed. Diether Schmidt, I (Dresden, n.d.).

51 *Die Zwanziger Jahre. Manifeste und Dokumente deutscher Künstler,* p. 93.

52 "Richtlinien der Novembergruppe," paragraph II.

53 *Der Gegner* [The opponent], II, Nos. 8–9 (1920–21).

54 Grosz, *Ein kleines Ja und ein grosses Nein.*

55 Erwin Piscator, *Das Politische Theater* [The political theater] (Berlin: 1929); new edition (East Berlin: 1968), I, 22.

56 *Dada-Almanach* (Berlin: 1920).

57 *Der Gegner,* II, No. 3 (1920–21), pp. 68–70.

58 Grosz, "Abwicklung," p. 38.

59 *Der Gegner,* I, Nos. 10–12 (1919–20), pp. 48–56.

60 G. G. L. (Gertrud Alexander) in *Die Rote Fahne* [The red flag], June 9, 1920.

61 *Die Aktion* [Action], X, Nos. 29–30 (1920).

62 *Die Rote Fahne,* June 24, 1920.

63 Berlin: Malik-Verlag, 1921.

64 *Der Ararat,* II, No. 5 (1921).

65 Tucholsky, "Der kleine Gessler und der grosse Grosz" [Little Gessler and the great Grosz] (1920), *Gesammelte Werke,* I, 752.

66 Tucholsky, "Dada-Prozess" [Dada trial] (1921), *Gesammelte Werke, I, 800ff.*

67 *Die Rote Fahne,* July 25, 1920.

68 Tucholsky, "Dada" (1920), *Gesammelte Werke,* I, 703.

69 *Die Rote Fahne,* March 9, 1927.

70 Willi Wolfradt, *George Grosz* (Leipzig: 1921).

71 Grosz, "Zu meinen neuen Bildern" [On my new pictures], *Das Kunstblatt,* V (1921), pp. 10–16.

72 Grosz, *Der Spiesser-Spiegel* [A mirror for Philistines], foreword.

73 Grosz, "Ein neuer Naturalismus? Eine Rundfrage" [A new Naturalism? A questionnaire], *Das Kunstblatt,* VI, No. 9 (1922), pp. 382–383.

74 Grosz and Herzfelde, *Die Kunst ist in Gefahr.*

75 Tucholsky, "Der kleine Gessler und der grosse Grosz."

76 It should be noted that these prices do not represent any absolute value but only a relative one. During the inflation of 1922–23 the Malik-Verlag set a base price which the book dealer then multiplied by a coefficient that the Malik-Verlag periodically revised. In this way, the price was kept in line with the value of the currency.

77 Tucholsky, "Dada."

78 Cited according to Beth Irwin Lewis, *George Grosz,* pp. 77–78.

79 According to an analysis by Alexander Uschakow in *Sinn und Form* [Meaning and form], XX, No. 6 (1968), pp. 1460–1473.

80 Bertolt Brecht, "Notizen über realistische Schreibweise" [Notes on realistic writing] (1940), in Bertolt Brecht, *Gesammelte Werke* [Collected works] (Frankfurt am Main: 1967), XIX, 368.

81 *Die Rote Fahne,* May 17, 1921.

82 *Ibid.,* June 24, 1923.

83 *Ibid.,* February 8, 1925.

84 *Ibid.,* June 14, 1925.

85 *Ibid.,* May 31, June 7, and June 21, 1925.

86 Brecht, foreword to *Trommeln in der Nacht* [Drums in the night], *Gesammelte Werke,* XVII, 960–961.

87 Exchange between Ohnesorge and George Grosz, Stenographic Record of the *Ecce Homo* Proceedings on February 16, 1924, before the Berlin Regional Court III, in *Das Tagebuch* [The journal], February 23, 1924, pp. 240–248.

88 Reprinted in *Die Rote Fahne,* June 18, 1924.

89 Cf. Ullrich Kuhirt, "Assoziation revolutionärer Bildender Künstler Deutschlands" (Asso) [Association of revolutionary German artists], *tendenzen* [tendencies] Nos. 66 and 67–68 (1970), and the exhibit catalog *Kunst als Waffe* [Art as a weapon] (Nürnberg: 1971).

90 The manifesto of Asso is reprinted in *Manifeste, Manifeste,* I, 385f.

91 Grosz, "Kurzer Abriss" [Short Sketch] *Situation 1924: Künstlerische und kulturelle Manifestationen* [Situation 1924: Artistic and cultural manifestations] (Ulm: n.d.), p. 22.

92 This middle part of *Die Kunst ist in Gefahr* is basically the same as the text of "Abwicklung," already cited frequently.

93 Letter to Otto Schmalhausen, May 27, 1927.

94 Kessler, *Tagebücher 1918–1937*, p. 577.

95 *Die Rote Fahne*, March 9, 1927.

96 *Ibid.*, November 24, 1927.

97 *Das Kunstblatt*, VI, No. 9 (1922), p. 390.

98 Franz Roh, *Nach-Expressionismus: Magischer Realismus* [Post-Expressionism: Magical Realism] (Leipzig: 1925).

99 In El Lissitzky and Hans Arp, *Die Kunst–Ismen* [The art-isms] (Zurich, Munich and Leipzig: 1925).

100 *Die Rote Fahne*, April 18, 1928.

101 Tucholsky, "Auf dem Nachttisch" [On the nighttable] (1930), *Gesammelte Werke*, III, 393.

102 Letter to Otto Schmalhausen, May 27, 1927.

103 Letter to Otto Schmalhausen, September 17, 1927.

104 Letter to Otto Schmalhausen, August 1927.

105 In *Die Welt am Abend* [The world-evening edition], September 9, 1930; facsimile reprint in *Aktionen, Bekenntnisse, Perspektiven: Berichte und Dokumente vom Kampf um die Freiheit des literarischen Schaffens in der Weimarer Republik* [Actions, positions, perspectives: Reports and documents on the struggle for the freedom of literary creativity in the Weimar Republic.] (Berlin and Weimar: 1966), p. 308.

106 Letter to Otto Schmalhausen, July 17, 1927.

107 Karl Scheffler, "George Grosz," *Kunst und Künstler* [Art and artists], XXVII (1929), pp. 269–272.

108 *Ibid.*, pp. 182–186.

109 Herbert Hofmann, "Auseinandersetzung mit George Grosz" [Critique of George Grosz] *Deutsche Kunst und Dekoration* [German art and decoration], LXVII (1931), pp. 364–368.

110 Glaser, "Juryfreie Kunstschau" [Non-juried art exhibition], *Kunst und Künstler*, XXVIII (1929–30), pp. 75–76.

111 Wolfradt, "George Grosz-Ausstellung," *Die literarische Welt* [The literary world], III, No. 2 (1927), p. 7.

112 Durus, "Ausstellung George Grosz: Einige Anmerkungen zu seiner jüngsten Entwicklung" [George Grosz exhibit. Some notes on his recent development], *Die Rote Fahne*, March 9, 1927.

113 *Die Rote Fahne*, May 21, 1927.

114 *Ibid.*, January 24, 1928.

115 *Ibid.*, February 12, 1928.

116 Durus, "George Grosz," *Eulenspiegel*, IV, No. 7 (1931), p. 111.

117 *Blätter der Piscatorbühne* [Newsletter of the Piscator Theater], February 1928.

118 The information and quotations used here are taken from the records of the Regional Court in Berlin-Moabit (File No. E 1 J.152.28–15.29).

119 Günther Anders, *George Grosz* (Zurich: 1961).

120 Herzfelde, "Wer das Buch liebt, verbietet es" [He who loves a book, bans it], *Die Weltbühne*, XXV, No. 12 (1929), p. 440.

121 The brochure in question is probably *Ein Kamp um Deutschland* [A struggle for Germany] (Berlin: 1933), in which Grosz's drawing of Christ from *Backdrop* is reproduced.

122 Undated letter (1927), written from Cassis, to Otto Schmalhausen.

123 Tucholsky, *Ausgewählte Briefe 1913–1935* [Selected letters 1913–1935), ed. Mary Gerold-Tucholsky and Fritz J. Raddatz (Reinbek: 1962), p. 141.

124 Letter to Elisabeth Lindner, September 7, 1932.

125 Tucholsky, *Ausgewählte Briefe,* pp. 310f.

126 Grosz, *Ein kleines Ja und ein grosses Nein,* Reinbek, 1955 and 1974. If not noted otherwise, the quotations that follow here come from this autobiography.

127 Cited according to Beth Irwin Lewis, *George Grosz,* p. 231.

128 *Der Querschnitt* [The cross section], XIII, No. 1 (1933), and *Kunst und Künstler,* XXXI (1932).

129 Radio interview made in 1958 (abridged). A tape recording of this interview is in the Staatliche Museen Preussischer Kulturbesitz, Kupferstichkabinett, West Berlin.

130 Grosz, "Über meine Zeichnungen" ("On My Drawings"), in Herbert Bittner *George Grosz* (New York, 1960; Cologne, 1961).

131 Letter from Felix J. Weil to George Grosz, October 29, 1941. I was not able to see the originals of either this letter or of the letters quoted hereafter, and I have quoted them as they appear in Hans Hess, *George Grosz* (London: 1974). Hess's study provides a detailed and significant analysis of Grosz's late period.

132 Letter to Felix J. Weil, November 1941.

133 Letter to Erich Cohn, January 19 (?), 1942.

134 Letter to Felix J. Weil, July 21, 1933.

135 Paul Ortwin Rave, *Kunstdiktatur im Dritten Reich* [Art dictatorship in the Third Reich] (Hamburg: 1949).

136 In exhibit catalog *A Piece of My World in a World without Peace,* Associated American Artists galleries (New York: 1946).

137 Letter to Elisabeth Lindner, August 15, 1948.

138 Letter to Priscilla Henderson, April 11, 1952.

139 Letter to A. and C. Grotewold, March 14, 1958.

The Grosz letters quoted in this book are available—either in the original or in photocopies—in the George Grosz Archives, Akademie der Künste, West Berlin.

Selected Bibliography

Portfolios and Books by Grosz

Erste George Grosz-Mappe [First George Grosz portfolio]. Berlin: Heinz Barger, 1917.
9 Lithographs

Kleine Grosz-Mappe [Small Grosz portfolio]. Berlin: Malik, 1917.
20 Lithographs

Gott mit uns. Politische Mappe [God on our side: a political portfolio]. Berlin: Malik, 1920.
9 Lithographs

Das Gesicht der herrschenden Klasse. 55 politische Zeichnungen [The face of the ruling class: 55 political drawings]. Berlin: Malik, 1921; reprint — Frankfurt am Main: Makol, 1972.

Im Schatten [In the shadows]. Berlin: Malik, 1921.
9 Lithographs

Mit Pinsel und Schere: 7 Materialisationen [With brush and scissors: 7 materializations]. Berlin: Malik, 1922.

Die Räuber. Neun Lithographien zu Sentenzen aus Schillers "Räuber" [The robbers: nine lithographs on Maxims from Schiller's The Robbers]. Berlin: Malik, 1922.

Abrechnung folgt! 57 politische Zeichnungen [Accounts to be settled: 57 political drawings]. Berlin: Malik, 1923; reprint — Frankfurt am Main: Makol, 1972.

Ecce Homo. Berlin: Malik, 1923.
 100 Pictures. Reprints — New York: Brussels, 1965; New York: Grove Press, 1966; Hamburg: Rowohlt, 1966; Frankfurt am Main: Makol, 1975.

Der Spiesser-Spiegel. 60 Berliner Bilder nach Zeichnungen mit einer Selbstdarstellung des Künstlers [A mirror for Philistines: 60 Berlin pictures based on sketches and with a self-portrait of the artist]. Dresden: Carl Reissner, 1925; reprint — Frankfurt am Main: Makol, 1973.

Hintergrund. 17 Zeichnungen zur Aufführung des "Schwejk" in der Piscator-Bühne [Backdrop. 17 drawings for the Piscator production of Schweik]. Berlin: Malik, 1928.

Die Gezeichneten. 60 Blätter aus 15 Jahren (Marked Men: 60 Pictures from 15 years). Berlin: Malik, 1930. Reprint — New York: Dover, 1971.

Das neue Gesicht der herrschenden Klasse. 60 neue Zeichnungen [The new face of the ruling class: 60 new drawings]. Berlin: Malik, 1930. Reprints — Stuttgart: Bassermann, 1966, and Frankfurt am Main: Makol, 1973.

Über alles die Liebe. 60 neue Zeichnungen (Love above All: 60 New Drawings). Berlin: Bruno Cassirer, 1930. Reprints — New York: Dover, 1971, and Frankfurt am Main: Makol, 1974.

Interregnum. New York: The Black Sun Press, 1936.
 64 Drawings. Reprint — Berlin: Propyläen, 1976.

Books about Grosz

Anders, Günther. *George Grosz*. Zurich: Die Arche, 1961.

Ballo, Ferdinando, ed. *Grosz*. Milan: Documenti d'Arte Contemporanea, 1946.

Bauer, John I. H. *George Grosz*. New York: Macmillan Co. and London: Thames and Hudson, 1954.

Bittner, Herbert. *George Grosz*. New York: Arts, Inc., 1960, and Cologne: DuMont Schauberg, 1961.

Dückers, Alexander. *George Grosz. Des druckgraphische Werk*. Frankfurt em Main: Propyläen, 1979.

Fischer, Lothar. *George Grosz in Selbstzeugnissen und Bilddokumenten* [George Grosz: His life as documented in pictures and extracts from his writings]. Reinbek: Rowohlt, 1976.

Hess, Hans, *George Grosz*. London: Cassell & Collier MacMillan, 1974.

Knust, Herbert (Herausgeber). *George Grosz. Briete 1913–1959* [George Grosz: Letters 1913–1959]. Reinbek: Rowohlt, 1979.

Lang, Lothar. *George Grosz*. East Berlin: Henschelverlag, 1966.

———. "George Grosz-Bibliographie" [George Grosz bibliography] in *Marginalien* [Marginalia], ed. Pirckheimer-Gesellschaft, East Berlin, XIII (1968).

Lewis, Beth Irwin. *George Grosz: Art and Politics in the Weimar Republic*. Madison, University of Wisconsin Press, 1971.

Mynona (Salomo Friedlaender). *George Grosz*. Dresden: Rudolf Kaemmerer, 1922. Reprint—Frankfurt am Main: Makol, 1975.

Sahl, Hans, ed. *George Grosz*. *Heimatliche Gestalten* [George Grosz: Figures from his homeland]. Frankfurt am Main: Fischer, 1966.

Schneede, Uwe M., ed. with contributions by Georg Bussmann and Marina Schneede-Sczesny. *George Grosz*. *Seine Kunst und seine Zeit* [George Grosz: His art and his times]. Stuttgart: Hatje, 1975, and London: Gordon Fraser, 1979.

Wolfradt, Willi. *George Grosz*. Leipzig: Klinkhardt und Biermann, 1921.

Exhibit Catalogs

George Grosz. Galerie Neue Kunst—Hans Goltz, Munich, 1920, with texts by Leopold Zahn and Willi Wolfradt.

George Grosz. Galerie von Garvens, Hannover, 1922, with text by Grosz.

George Grosz. Galerie Alfred Flechtheim, Berlin, 1926, with texts by Carl Einstein, Gottfried Benn, Marc Neven, Max Herrmann-Neisse and Florent Fels.

George Grosz 1893–1959. Akademie der Künste, Berlin, 1962, with texts by Erwin Piscator, Walter Mehring, Friedrich Ahlers-Hestermann.

Ohne Hemmung. Gesicht und Kehrseite der Jahre 1914–1924, schonungslos enthüllt von George Grosz [Without inhibition. The face—and what's behind it—of the years 1914–1924, Mercilessly Unmasked by George Grosz]. Galerie Meta Nierendorf, Berlin, 1963, with text by Willi Wolfradt.

George Grosz 1893–1959. Graphische Sammlung Albertina, Vienna, 1965, with texts by Walter Koschatzky, Walter Kasten and Erwin Piscator.

George Grosz: Zeichnungen und Lithographien [George Grosz: drawings and lithographs]. Staatliche Kunstsammlungen, Dresden, 1965.

George Grosz. John Heartfield. Württembergischer Kunstverein, Stuttgart, 1969, with texts by Grosz and Uwe M. Schneede.

George Grosz. Frühe Druckgraphik, Sammelwerke, Illustrierte Bücher 1914–1923 [George Grosz: early graphics, collections, illustrated books 1914–1923]. Staatliche Museen Preussischer Kulturbesitz, Kupferstichkabinett, Berlin, 1971.

Theatrical Drawings and Watercolors by George Grosz. Busch-Reisinger Museum, Harvard University, 1973.

List of Illustrations

Color Plates

1 *To Oskar Panizza (Widmung an Oskar Panizza),* 1917–18
 Oil on canvas, 140 × 110 cm
 Staatsgalerie Stuttgart

2 *Childbirth (Niederkunft),* 1917
 Watercolor and pen and ink, 50.8 × 35.3 cm
 Staatsgalerie Stuttgart

3 *Suicide (Selbstmörder),* 1918
 Watercolor and pen and ink, 50.8 × 36.5 cm
 Galerie Nierendorf, Berlin

4 *Daum marries her pedantic automaton George,* 1920
 Watercolor, collage, pen and ink, and pencil, 42 × 30.2 cm
 Galerie Nierendorf, Berlin

5 *Strength and Grace (Kraft und Anmut),* 1922
 Watercolor and pen and tusche, 53.3 × 44 cm
 Wallraff-Richartz-Museum, Cologne
 (Graphische Sammlung, Sammlung Haubrich)

6 *Portrait of Max Herrmann-Neisse,* 1925
 Oil on canvas, 100 × 101 cm
 Kunsthalle Mannheim

7 *Pillars of Society (Stützen der Gesellschaft),* 1926
 Oil on canvas, 200 × 108 cm
 Nationalgalerie Berlin (West)

8 *Modern Short Story (Aktuelle Kurzgeschichte),* 1932
 Watercolor and pen and tusche, 59 × 46 cm
 The Estate of George Grosz, Princeton, N.J.

Black and White Illustrations

1 Illustration for *Ulk,* 1910
 Location unknown

2 Illustration, 1911
 Location unknown

3 *Street Crowd Gathering (Auflauf),* 1912
 Pen and ink and watercolor
 Location unknown

4 *Adultery (Ehebruch),* 1913
 Pen and ink wash, 19.2 × 28.7 cm
 The Estate of George Grosz, Princeton, N.J.

5 *Double Murder in the Rue Morgue (Der Doppelmord in der Rue Morgue),* 1913
 Location unknown

6 *Sex Murder (Lustmord),* 1912–13
 Pen and ink wash, 19.7 × 24.8 cm
 Privately owned

7 *Homunculus,* 1912
 Charcoal, 27 × 50 cm
 The Estate of George Grosz, Princeton, N.J.

8 *The End of the Road (Das Ende der Strasse),* 1913
 Pencil and watercolor, 27.7 × 21.7 cm
 Museum of Modern Art, New York
 (Stephen C. Clark Fund)

9 *Street Fight (Strassenkampf),* 1914
 Pen and ink, 28.4 × 18.6 cm
 The Estate of George Grosz, Princeton, N.J.

10 *The Grenade (Die Granate),* 1915
 Pen and ink, 24.8 × 19.9 cm
 The Estate of George Grosz, Princeton, N.J.

11 *Prisoners (Gefangen),* 1915
 Lithograph, 31.5 × 24.4 cm

12 *General,* ca. 1916
 Charcoal, 20 × 12.4 cm
 Formerly, Peter Deitsch Fine Arts, New York

13 *Sticking It Out (Durchhalten),* 1915
 from *Neue Jugend* [New youth], vol. 1, Nr. 7 (1916)

14 *Tightrope Walker (Seiltänzerin)*, ca. 1916
Pen and ink and pastels, 25.2 × 19 cm
Paul Hofmeister, Hamburg

15 *Riot of Madmen (Krawall der Irren)*, 1915
Pen and ink, 13.1 × 22.6 cm
Sammlung B. S., Berlin

16 *Pandemonium*, 1915-16
Pen and ink, 47 × 30.5 cm
Mr. and Mrs. Bernhard Reis, New York

17 *Roads Men Take (Menschenwege)*, 1915
From *Die weissen Blätter* [The white pages], vol. 4, Nr. 11 (1916)

18 *Street Scene with Artist (Strassenszene mit Zeichner)*, ca. 1917
Pen and ink, 33.4 × 21.5 cm
Staatsgalerie Stuttgart (Graphische Sammlung)

19 *Café (Caféhaus)*, 1914
Pen and ink and colored pencil, 25.5 × 21 cm
Murray B. Cohen, New York

20 *Reminiscence of New York (Erinnerung an New York)*, 1916
From *Erste George Grosz-Mappe* [First George Grosz portfolio], 1917

21 *Texas Scene for My Friend Chingachgook (Texasbild für meinen Freund Chingachgook)*, 1916
From *Erste George Grosz-Mappe* [First George Grosz portfolio], 1917

22 *The Gold Prospector (Der Goldgräber)*, 1916
Pen and ink, 41 × 29.5 cm
Murray B. Cohen, New York

23 *Detective Story (Detektivgeschichte)*, 1918
Pen and tusche, 57 × 46.5 cm
Privately owned

24 *At Night (Nachts)*, 1917
Brush and tusche, 50.9 × 36.2 cm
Galerie Nierendorf, Berlin

25 *When it was all over, they played cards (Als alles vorbei war, spielten sie Karten)*, 1917
Pen and ink, 25 × 31 cm
The Estate of George Grosz, Princeton, N.J.

26 *Sex Murder on Ackerstrasse (Sexmord in der Ackerstrasse)*, 1916
 Pen and ink, 35.6 × 27.5 cm
 The Estate of George Grosz, Princeton, N.J.

27 *Murderer (Mörder)*, 1917
 From *Ecce Homo*, 1923

28 *Street Scene (Strassenszene)*, ca. 1917
 Pen and ink, 23.5 × 16 cm
 Sammlung Paul Hofmeister, Hamburg

29 *Contrasts (Gegensätze)*, 1917
 Brush and tusche, 59 × 46.1 cm
 Staatsgalerie Stuttgart (Graphische Sammlung)

30 *Tragedy (Tragödie)*, 1917
 Pen and tusche, 51.1 × 36.6 cm
 The Estate of George Grosz, Princeton, N.J.

31 *Self-Portrait (Selbstporträt)*, 1917
 Reed pen and ink, 51.5 × 36.5 cm
 Privately owned

32 *Dead Serious (Tierischer Ernst)*, 1918
 From *Die Gezeichneten* [Marked men], 1930

33 *Bad Conscience (Schlechtes Gewissen)*, 1918
 From *Die Gezeichneten* [Marked men], 1930

34 Prospectus for *Kleine Grosz-Mappe* [Small Grosz portfolio], 1917

35 *The guilty party goes undetected (Der Schuldige bleibt
 unerkannt)*, 1919
 Collage and pen and ink, 50.7 × 35.5 cm
 Art Institute of Chicago

36 *How the Court Should Look (Wie der Staatsgerichtshof aussehen
 müsste)*, 1919
 From *Der blutige Ernst* [Dead serious], vol. 1, Nr. 3 (1919)

37 *Here's to Noske! The proletariat has been made harmless!
 (Prost Noske! Das Proletariat ist entwaffnet!)*, 1919
 From *Die Pleite* [Bankruptcy], vol. 1, Nr. 3 (1919)

38 *The White General (Der weisse General)*, 1922
 From *Die Pleite* [Bankruptcy], Nr. 8 (1923)

39 *After Work (Feierabend),* 1919–20
From *Gott mit uns* [God on our side], 1920

40 *Like Master, like Man—Even revolution brings profit (Wie die Herren so die Knechte—auch Revolution ist ihnen ein Geschäft),* 1920
From *Das Gesicht der herrschenden Klasse* [The face of the ruling class,] 1921

41 *When the bourgeois is enraged—(Der Bürger hetzt—)*

42 *—the proletarian has to pay (—und der Prolet muss bluten),* 1919
From *Abrechnung folgt!* [Accounts to be settled], 1923

43 *For German Law and Morality (Für deutsches Recht und deutsche Sitte),* 1920
From *Gott mit uns* [God on our side], 1920

44 *The Perfection of Democracy (Die vollendete Demokratie),* 1920
From *Gott mit uns* [God on our side], 1920

45 *It smells of common people here! ('s riecht hier nach Pöbel!),* 1921
From *Des Gesicht der herrschenden Klasse* [The face of the ruling class], 1921

46 *A Happy New Year! (Ein gesegnetes Neues Jahr!),* 1920
From *Die Pleite* [Bankruptcy], vol. 1, Nr. 6 (1920)

47 *No one else turns them out like this (Den macht uns keiner nach),* 1920
From *Gott mit uns* [God on our side], 1920

48 *Where the Dividends Come From— (Wo die Dividenden herkommen—)*

49 *—Where They End Up (—wo sie hinkommen),* 1921
From *Des Gesicht der herrschenden Klasse* [The face of the ruling class], 1921

50 *In the Bar (Im Wirtshaus),* 1921
Tusche, 65 × 52.5 cm
Privately owned

51 *At the Regulars' Table (Am Stammtisch),* 1919
Reed pen and tusche, 50 × 68 cm
Galerie Nierendorf, Berlin

52 *Death's Procurers (Zuhälter des Todes),* 1919
From *Gott mit uns* [God on our side], 1920

53 *Germany, A Winter's Tale (Deutschland, ein Wintermärchen),* 1917–19
Location unknown

54 *Republican Automatons (Republikanische Automaten),* 1920
Watercolor and pen and ink, 60 × 47.3 cm
Museum of Modern Art, New York

55 *Handsome Fritz (Der schöne Fritz),* 1920
Location unknown

56 *The Faith Healers (Die Gesundbeter),* 1918
From *Gott mit uns* [God on our side], 1920

57 *The Communists fall—and the stocks rise (Die Kommunisten
fallen—und die Devisen steigen),* 1920
From *Gott mit uns* [God on our side], 1920

58 *In Front of the Factories (Vor den Fabriken),* 1921
From *Im Schatten* [In the shadows], 1921

59 *War Cripples and Workers (Kriegsinvaliden und Arbeiter),* 1921
From *Im Schatten* [In the shadows], 1921

60 *At Five in the Morning! (Früh um 5 Uhr!),* 1921
From *Im Schatten* [In the shadows], 1921

61 *Shot While Trying to Escape (Auf der Flucht erschossen)*
From *Das Gesicht der herrschenden Klasse* [The face of the ruling class], 1921

62 *Marloh After—Anyone who wants to be a knight of the swastika . . .
(Marloh jetzt—Was ein Haken-kreuzritter werden will. . .)*

63 *—and Marloh Before . . . has to start practicing early
(—und einst . . . übt sich beizeiten)*
From *Abrechnung folgt!* [Accounts to be settled], 1923

64 *Dependency Decreed by God (Gottgewollte Abhängigkeit)*
From *Das Gesicht der herrschenden Klasse* [The face of the ruling class], 1921

65 *Inflation,* 1921
From *Im Schatten* [In the shadows], 1923

66 *My disability pay— (Meine Rente—)*

67 *= a Havana cigar (= eine Havanna)*
From *Abrechnung folgt!* [Accounts to be settled], 1923

68 *If soldiers weren't so stupid, they would have run away on
me long ago (Wenn Soldaten nicht solche Dummköpfe wären,
würden sie mir schon längst davongelaufen sein—Fridericus Rex)*
From *Abrechnung folgt!* [Accounts to be settled], 1923

69 *I'll see that things are so bad in my territory that the*
 people will think potatoes and thin beer are a holiday treat
 (In meinem Gebiet soll's so weit kommen, dass Kartoffeln und
 Dünnbier ein Traktament für Festtage werden)
 From *Die Räuber* [The robbers], 1922

70 *I'll destroy anything that prevents me from being absolute*
 master here (Ich will alles um mich her ausrotten, was mich einschränkt, dass ich
 nicht Herr bin)
 From *Die Räuber* [The robbers], 1922

71 *Lions and leopards feed their young; even ravens serve up*
 carrion to their little ones (Löwen und Leoparden füttern
 ihre Jungen, Raben tischen ihren Kleinen auf. . .)
 From *Die Räuber* [The robbers], 1922

72 *Right resides in the fist of the mighty (Das Recht wohnet beim Überwältiger)*
 From *Die Räuber* [The robbers], 1922

73 *Hitler the Savior (Hitler der Retter),* 1923
 From *Die Pleite* [Bankruptcy], Nr. 8 (1923)

74 *View of the City (Stadtgesicht),* 1928–29
 Oil on canvas, 80.5 × 60.5 cm
 Privately owned

75 *Cripple (Krüppel),* 1923
 Brush and ink, 59.1 × 45.9 cm
 The Estate of George Grosz, Princeton, N.J.

76 *Standing Nude (Stehender Akt),* 1924
 Pencil, 59.3 × 38 cm
 The Estate of George Grosz, Princeton, N.J.

77 *Self-Portrait in the Role of Admonisher (Selbstporträt als*
 Warner), 1926
 Oil on canvas, 90 × 70 cm
 Galerie Nierendorf, Berlin

78 *Grosz's Mother (Mutter Grosz),* 1925
 Pencil, 60 × 46.4 cm
 The Estate of George Grosz, Princeton, N.J.

79 *Man out of Work (Arbeitsloser),* 1924
 Pencil, 63 × 45.6 cm
 The Estate of George Grosz, Princeton, N.J.

Frontispiece: George Grosz in 1926. In the background is his painting
 Pillars of Society (see Color Plate 7).

Photo Credits

Berlin, Jörg P. Anders: Illus. 39, 43, 44, 47, 52, 56, 57
Berlin, Yvel Hyppolite: Illus. 58, 59, 65
Berlin, Hermann Kiessling: Illus. 14, 51
Berlin, Nationalgalerie: Color Plate 7
Berlin, Galerie Nierendorf: Color Plates 3, 4; Illus. 24
Berlin, Galerie Pels-Leusden: Illus. 28
Chicago, Art Institute: Illus. 35
Hamburg, Elke Walford: Illus. 1–12, 16, 25, 26, 30, 34, 53, 55, 75–79, 87–90, 92
Cologne, Wallraf-Richartz-Museum: Color Plate 5
Mannheim, Fotostudio Bergerhausen: Color Plate 6
Marbach am Neckar, Schiller-Nationalmuseum: Illus. 84, 85, 86
New York, eeva-inker: Illus. 19, 22
New York, Museum of Modern Art: Illus. 54
Saarbrücken, Atelier Reichmann: Illus. 60
Stuttgart, Staatsgalerie: Color Plate 1
Stuttgart, Staatsgalerie, Graphische Sammlung: Color Plate 2; Illus. 18, 20, 21, 29, 69, 70–72
Author's files: Color Plate 8; Frontispiece; Illus. 13, 17, 27, 36, 37, 38, 40–42, 45 46, 48, 49, 61–64, 66–68, 73, 80–91, 93

Index

Page references for illustrations are printed in italic type.

BARRON'S POCKET ART SERIES

These attractive low-priced books contain an average of 100 reproductions, many in full color. Each volume 4½″ x 7⅛″.

ART NOUVEAU,
Sterner. The exotic turn-of-the-century aesthetic movement.
93 ill. (19 color), $5.95

AUBREY BEARDSLEY,
Hofstatter. Fabulous collection of his elegantly decadent illustrations. 140 ill., $3.95

THE BLUE RIDER,
Vogt. Fascinating German-based Expressionist school.
87 ill. (20 color), $3.95

JOSEPH BEUYS,
Adriani, Konnertz & Thomas. The stormy career of Europe's most intriguing avant-garde artist. 100 ill., $6.95

MARC CHAGALL,
Keller. Includes many rarely-seen examples of his early work.
92 ill. (24 color), $4.95

DICTIONARY OF FANTASTIC ART,
Krichbaum & Zondergeld. Comprehensive guide to an increasingly popular genre.
124 ill. (39 color), $6.95

CASPAR DAVID FRIEDRICH,
Jensen. The finest paperback study of Germany's greatest landscape painter. 87 ill. (24 color), $4.95

ANTONI GAUDI,
Sterner. Photo-filled study of Gaudi's landmark architectural creations in Barcelona.
95 ill. (30 color), $5.95

GEORGE GROSZ,
Schneede. Trenchant satirical drawings and paintings by a 20th century master.
100 ill. (8 color), $5.95

PAUL KLEE,
Geelhaar. Outstanding selection of works by the "thinking eye of modern art." 91 ill. (42 color), $4.95

RENE MAGRITTE,
Schneede. Surrealistic images both witty and terrifying.
76 ill. (16 color), $4.95

PICASSO, Photos 1951-72,
Quinn. Picasso's late career, documented in fascinating photos and text. 127 ill., $3.95

REMBRANDT,
Haak. New perspective on one of the most profound of all painters.
82 ill. (16 color), $4.95

PETER PAUL RUBENS,
Warnke. The celebrated Flemish master and his dynamic composi-tions. 15 ill. (21 color), $4.95

KÜPPERS' BASIC LAW OF COLOR THEORY,
Küppers. Innovative illustrated guide for art students and profes-sionals. 152 ill. (66 color), $7.95

KÜPPERS' COLOR ATLAS,
Küppers. Screen tint grids show 5500 colors obtained through various combinations and saturations. 75 ill. (48 color), $10.95

BARRON'S, 113 Crossways Park Drive, Woodbury, New York 11797